Impressions of the Riviera

MONET, RENOIR, MATISSE
AND THEIR CONTEMPORARIES

Impressions OF THE Riviera

MONET, RENOIR, MATISSE
AND THEIR CONTEMPORARIES

KENNETH WAYNE

with essays by

JOHN HOUSE

KENNETH E. SILVER

The Portland Museum of Art gratefully acknowledges
Scott M. Black, whose leadership and generosity made
this exhibition and catalogue possible.

Impressions of the Riviera is also funded by a major grant from
The Florence Gould Foundation. This exhibition is sponsored
by Bell Atlantic, with additional support provided by
Portland Press Herald/Maine Sunday Telegram.

Portland Press Herald / Maine Sunday Telegram

This catalogue was produced in conjunction with the exhibition
Impressions of the Riviera: Monet, Renoir, Matisse, and their Contemporaries,
which was organized by the Portland Museum of Art and presented
from June 25–October 18, 1998.

PUBLISHED BY
Portland Museum of Art
Seven Congress Square, Portland, Maine 04101

DISTRIBUTED BY
University of Washington Press
P.O. Box 50096, Seattle, WA 98145-5096

FRONT COVER (DETAIL) AND BACK COVER
Pierre Auguste Renoir, *The Beach at Le Lavandou, French Riviera,* 1894,
Oil on canvas, 18 1/8 x 21 15/16 in.
Sterling and Francine Clark Art Institute. Gift of Halleck and
Sarah Barney Lefferts, 1964.9

CURATOR
Kenneth Wayne

CATALOGUE DESIGN
Michael Mahan Graphics, Bath, Maine

EDITOR
Fronia W. Simpson

PRINTER
J. S. McCarthy Printers, Augusta, Maine

Library of Congress Catalog Card Number: 98-65387

ISBN: 0-916857-12-3

CONTENTS

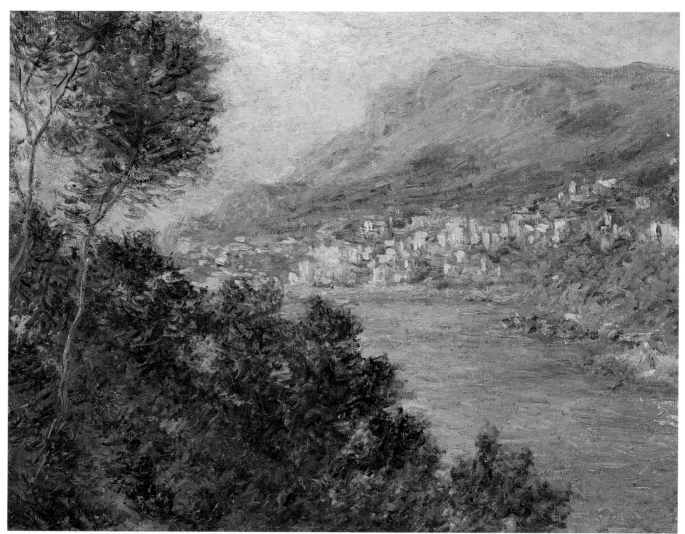

Fig. I Claude Monet *Monte Carlo vu de Roquebrune (Monte Carlo seen from Roquebrune)*, 1884, oil on canvas, 25 7/8 x 32 in., Scott M. Black Collection.

SPONSOR'S STATEMENT

The dancing sunlight on the Mediterranean glittering like well-polished diamonds, the high azure sky with its promise of another perfect summer day, and the mountains flowing gently to the sea; these are the timeless qualities that make the Côte d'Azur so enchanting. As the French are wont to say, "C'est très jolie!" I first traveled to the South of France—Cannes, Saint-Tropez, and Monaco—in 1976 and was beguiled by the combination of pristine natural beauty and the elegant French culture. It is no accident that, over the past twenty-two years, I have returned to the Côte d'Azur nearly every summer, literally traversing the entire coastline from Marseilles to Menton. For me, Cannes shall always be the most beautiful community, with its sweeping Croisette, its median strips planted with palm trees and flowers, and its beautiful public parks and reflecting pools.

There are nuances to the natural beauty of the South. The terrain is more rugged as one moves west toward Aix-en-Provence or Le Lavandou; more refined as one moves east toward Saint-Jean-Cap-Ferrat or Monaco. This variegated landscape with its unique light attracted many of the greatest painters of the past one hundred years, challenged their artistic capabilities, and provided them solace in their moments of doubt. In 1884 Claude Monet, the master of French landscape painting, visited the Riviera (Bordighera) for the first time and was overwhelmed by the intensity of the Mediterranean sunlight. The florid reds in *Cap Martin, near Menton* (fig. 5) or the unfinished quality of the *Bridge of Acquadolce* attest to Monet's internal struggles. As my painting *Monte Carlo vu de Roquebrune* (fig. 1) demonstrates, he overcame his initial difficulties and produced the luminescent reflections of water he had displayed at Argenteuil.

Among the great South of France painters, Monsieur Cézanne is the only native son. Although he journeyed north to Pontoise in 1872 to imbibe the Impressionist style from his friend Pissarro, it was the environs of Aix and L'Estaque that inspired his greatest paintings. My *Trees in the Jas de Bouffan* of 1875-76 (fig. 6) is a transitional painting. The foreground with the picket fence has traditional Impressionist comma brushwork. Closer examination of the trees shows the beginning of his constructivist brushstroke, a harbinger of his future style. For Cézanne, Mont Sainte-Victoire had a spiritual quality, his Mount Olympus. Although he created visual images "more solid" than Impressionism, his blue shades in *The Bay at L'Estaque* and his orange and green hues in the Château Noir series actually exist in nature.

Throughout my years of collecting, I have always been impressed by the respect that each successive generation of French painters has accorded its predecessors. Monet and Renoir inaugurated Impressionism at La Grenouillière (Chatou) in 1869. Derain and Vlaminck returned to Chatou in 1905 and introduced the Fauve period. Similarly, the Côte d'Azur provided this same legacy. The torch was passed from the nineteenth-century masters (Monet, Renoir, Cézanne) to the Neo-Impressionists (Signac, Cross, Van Rysselberghe) to the Fauves (Derain, Braque, Dufy) to the Modernists (Picasso, Matisse, Braque, and Chagall). Monet painted in Antibes in 1888. Unsurprisingly, both Signac and Cross produced divisionalist canvases of Antibes in the twentieth century. In my *Le Nuage Rose* (fig. 9), one sees the juxtaposition of sailboats and commercial ships reminiscent of Monet's masterpiece, *The Terrace at Sainte-Adresse*. The first great Cubist painting, Braque's *Viaduct at L'Estaque* (1907), can be characterized as an *hommage à Cézanne*. Despite the abundance of talented French painters who gravitated to the South of France, one must ask the scholarly question, "Why did Manet, Degas, Pissarro, Seurat, or Cassatt not venture south?"

As a native Portlander, I am extremely pleased to help sponsor this beautiful Côte d'Azur exhibition. The interplay of the exquisite physical beauty of the region with its shimmering sunlight produced one of the greatest epochs in painting since the High Renaissance in Florence. It is yours to enjoy. I dedicate this year's exhibition to my good friend, Robert Boardingham of the Museum of Fine Arts, Boston, who passed away last December. He accompanied me to the Sotheby's auction in 1995 when I purchased both my Cézanne and Cross and was overjoyed with my success in obtaining the Cézanne. He was a great scholar. More important, Robert was a great friend of my family, and will be sorely missed.

Scott M. Black

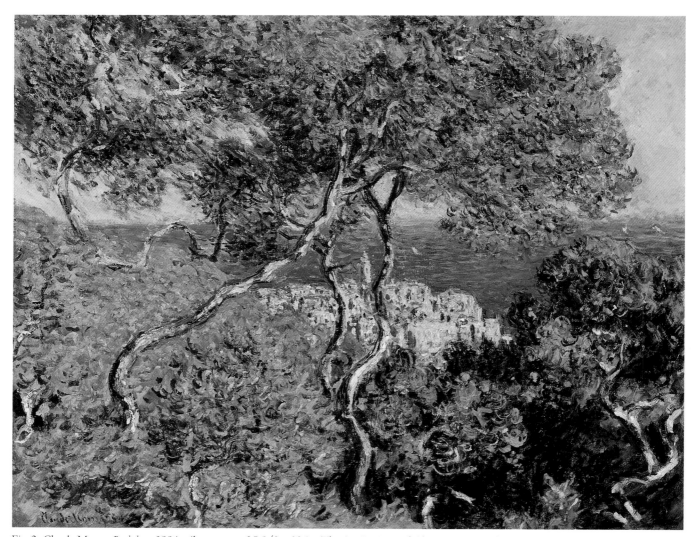

Fig. 2 Claude Monet, *Bordighera*, 1884, oil on canvas, 25 1/2 x 32 in., The Art Institute of Chicago. Potter Palmer Collection, 1922.426.

INTRODUCTION & ACKNOWLEDGMENTS

*I*mpressions of the Riviera resulted from a stroll that I took through the Portland Museum of Art's galleries one afternoon in search of an exhibition topic. I realized that many of the best paintings on view at the Museum were all painted within miles of each other on the French Riviera. These works include: Monet's *Monte Carlo seen from Roquebrune* (fig. 1), Cross's *Antibes in the Afternoon* (fig. 8), Signac's *Antibes, the Pink Cloud* (fig. 9), Van Rysselberghe's *Regatta* (fig. 7), Cézanne's *Trees in the Jas de Bouffan* (fig. 6), Renoir's *L'Estaque* (fig. 11), Dufy's *Boats in Martigues* and *Bal du 14 Juillet à Vence* (figs. 12 and 40), and Matisse's *Three O'Clock Sitting* (fig. 52). The number, variety, and quality of these works underscored to me the important role that the Riviera has played as an art capital, inspiring several generations of modernist artists. Somehow this rich history has been slighted. Perhaps the pleasure-seeking reputation of the area has seemed at odds with serious art-historical consideration. An exhibition was born.

Modernism and the Riviera are indeed intimately linked. The Riviera was of central importance to Impressionist artists Monet and Renoir and to Neo-Impressionist artists Signac, Cross, and Van Rysselberghe who were attracted by its light. Fauvist artists Matisse, Braque, and Othon Friesz revelled in its bright colors. It was in Saint-Tropez in the summer of 1904 that Signac advised Matisse and Fauvism soon developed. Ironically, "School of Paris" artists Archipenko and Modigliani produced many of their best-known and most important works, not in Paris, but on the Riviera. Photographers Brassaï, Henri Cartier-Bresson, Man Ray, and especially Jacques-Henri Lartigue took some of their most classic, memorable images on the Riviera.

The period in which these artists worked, 1880–1940, is the focus of this exhibition. Artists have continued to work on the Riviera since that time, most prominently Arman, Ben, César, Yves Klein, and Martial Raysse. However, their works—with their objects, words, and paint splashes—are of an altogether different character from the earlier works featured here. The earlier group provided more than enough examples to make a focused show.

While the eastern boundary of the French Riviera is firmly accepted—Menton, on the border with Italy (see map on p. 80)—the western one is open to question. Saint-Tropez, Hyères, and La Ciotat have all been suggested. I have decided to go a little farther west, taking works from Marseille, Estaque, and Martigues. My reason is simple: the works selected have a similar spirit to others in the exhibition and clearly belong to that group; they share the same interest in light and modernist exploration. (Italy has its own Riviera, of course, and we are fortunate to have a Monet painting of Bordighera from the Art Institute of Chicago, fig. 2.)

Putting together an exhibition and its catalogue is a monumental task. I would like to express my profound gratitude to the lenders (see list on p. 80) for parting with their precious works to enable us to mount this show. For their help in locating or securing works, materials, or information, I would like to thank the following

individuals: Martine d'Astier; March Avery; Frederic Bancroft; Stephanie Barron; Patricia Berman; Scott Black; the late Robert J. Boardingham; Peter Boris; Sir Alan Bowness; Sophie Bowness; Donna Cassidy; Elizabeth Chapin; Marie Noëlle Delorme; Honoria Murphy Donnelly; John Donnelly; Patrice Donoghue; Douglas Druick; Arne Eggum; Carol Eliel; Sandra Ericson; Larry Fineberg; Richard Feigen; Valerie Fletcher; Dominique Forest; Sarah and Neil Gallagher; Joseph Garver; Colette Giraudon; Frances Archipenko Gray and her assistant Valerie Tekavec; Deanna M. Griffin; Gloria Groom; Maarten van de Guchte; Fanny Guillon-Lafaille; Robert Haller; Michaël Houlette; Julia Kirby; Billy Klüver; Kristine Krueger; Alyson Kuhn; Marilyn Kushner; Brigitte Léal; Ellen Lee; Tiffany Lee; Claude Leroy; Steven Z. Levine; Anne Lyden; Nanette Maciejunes; Julie Martin; Maria-Gaetana Matisse; Achim Moeller; Leigh Morse; Maureen Murphy; Terence Murphy; Annegreth Nill; David Norman; Harold and Peggy Osher; John W. Payson; Klaus Perls; Olga Picabia; Joachim Pissarro; Eliza Rathbone; Peter Rathbone; Sabine Rewald; John Richardson; Gail Scott; George Shackelford; Beata Sloan; Natasha Staller; Gail Stavitsky; Anna M. Swinbourne; Ann Temkin; Pierre Théberge; Christopher Tiné; Gary Tinterow; Elizabeth Hutton Turner; Ornella Volta; Bret Waller; Jake Wien; John Young; Debbie Zorach; and Peggy Zorach.

Franny and Daniel Zilkha generously offered my wife, Olivia, and me the use of their Riviera villa for two weeks in July 1997; located near Sainte Maxime, in the middle of the Riviera, it provided an excellent base for visiting the region.

I am also grateful to Kimberley Greeley Brown and her father, Norman Greeley Brown, for appearing in my life in the middle of this project. The materials that they provided, descended from their ancestor Russell Greeley and his Château de Clavary near Grasse, became the inspiration and basis for the essay "Château and Villa Life." Kim joined Olivia and me on the Riviera to visit the Château de Clavary. We had a memorable time of joint discovery.

Christopher Green and Patrick Elliott provided valuable commentary on an early version of my essay "Montparnasse Heads South," when it was my M.A. thesis at the Courtauld Institute of Art (on Archipenko). Nina Boguslavsky kindly translated several Russian documents for me. Olivia and her parents, Noémi and Daniel Mattis, graciously helped with the trickier French translations. The staff of the interlibrary loan department at the Portland Public Library relentlessly tracked down dozens of books for me, even very obscure ones. The staff at the Fine Arts Library at Harvard University was also helpful.

I would like to thank our two esteemed guest authors, Professors John House and Kenneth Silver, for their engaging essays which make an important contribution and are a pleasure to read. We are privileged and honored to be able to feature their fine scholarship in this catalogue. Kenneth Silver also acted as a consultant on the exhibition, providing valuable information, suggestions and leads on works.

Fronia W. Simpson edited this catalogue with great thoughtfulness and attention. Mahan Graphics of Bath, Maine, presented all of the catalogue material to advantage with their exceptional design work.

Fig. 3 Claude Monet, *Plage de Juan-les-Pins (Beach at Juan-les-Pins)*, 1888, oil on canvas, 28 3/4 x 36 1/4 in., Acquavella Galleries, Inc.

Several colleagues here at the Portland Museum of Art have provided valuable registrarial and curatorial support, including: Susan Anable, Michele Butterfield, Aprile Gallant, and Jessica Nicoll. Curatorial Assistant Jessica Skwire did an outstanding job assisting with the exhibition planning, preparation, and implementation, assuring that the process progressed in a smooth and timely manner. Her vigilant administrative support was key to the success of this project. Museum preparators Stuart Hunter and Gregory Welch have used their remarkable talents and skills to help create another memorable exhibition installation. I am very grateful to Director Daniel O'Leary and the Board of Trustees for their enthusiastic support of this project from its inception.

I am especially pleased to recognize the sponsors, for they have made this exhibition and catalogue possible: Scott M. Black, The Florence Gould Foundation, Bell Atlantic, and the *Portland Press Herald/Maine Sunday Telegram.* Their support is profoundly appreciated.

Kenneth Wayne, Joan Whitney Payson Curator

THAT MAGICAL LIGHT

IMPRESSIONISTS AND POST-IMPRESSIONISTS ON THE RIVIERA

JOHN HOUSE

During the later nineteenth century, the physical experience of France's Mediterranean coast was transformed by the arrival of the railway and the rapid development of tourism. Yet the painters' visions of this coast largely ignored these changes in favor of quite different concerns: the problems of translating the effects of the southern light into paint and the cultural associations of the region with classical history and myth. At first sight, this suggests a complete disjunction between art and reality—that the art was fundamentally escapist in its purposes. But the relationship between the paintings and the world they claimed to depict was more complex than this; in many ways, the visions that the paintings offered were expressions of the same values that attracted both tourists and developers to the South.

The railway link between Paris and Marseille was completed in 1855, replacing a long and complex trip by coach and river steamer with a single journey of less than twenty-four hours. The railway reached Cannes in 1863 and Menton, on the Italian border, in 1868, running eastward from Marseille along the coast and cutting through its notoriously intractable mountain ranges. No longer did the traveler need to explore the spectacular scenery of the celebrated and sinuous Corniche road.

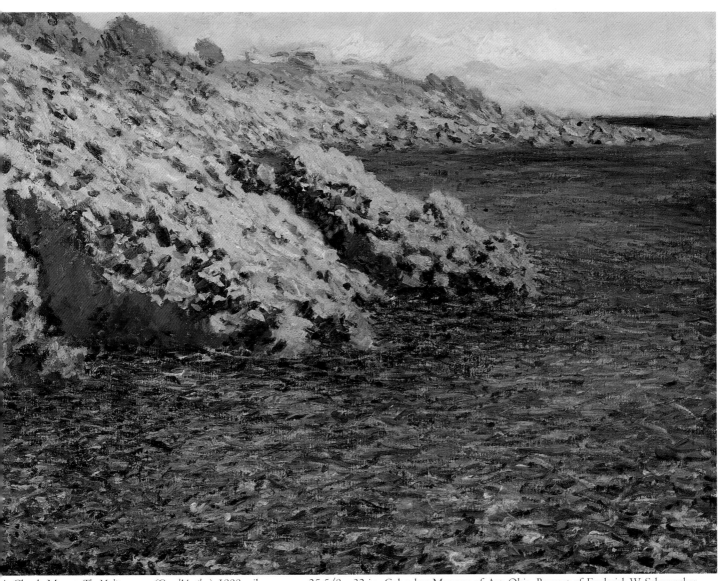

4 Claude Monet, *The Mediterranean (Cap d'Antibes)*, 1888, oil on canvas, 25 5/8 x 32 in., Columbus Museum of Art, Ohio. Bequest of Frederick W. Schumacher, 47.093.

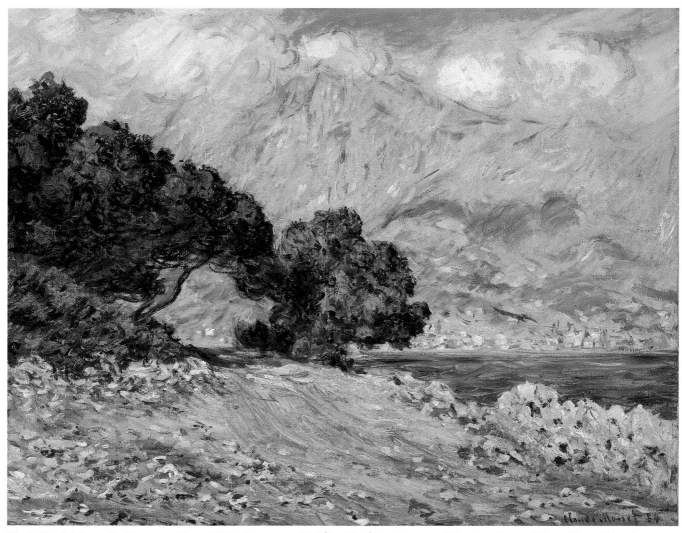

Fig. 5 Claude Monet, *Cap Martin, near Menton,* 1884, oil on canvas, 26 1/2 x 32 1/8 in., Museum of Fine Arts, Boston. Juliana Cheney Edwards Collection, 25.128.

Unlike today, the Mediterranean coast in the later nineteenth and early twentieth centuries was a winter refuge, not a summer playground; the summer climate was considered too hot and unhealthy. Northern city dwellers, particularly those suffering from tuberculosis, were encouraged to spend the winter on the coast, where the climate was mild and temperate because of the sheltering mountains.[1] The coast was especially popular with English visitors, among them Queen Victoria and the future King Edward VII—the latter attracted as much by the social high-life of Cannes as by the health-giving fresh air and exercise advocated in the many well-meaning books published on the region.

However, these manuals of medical travel did not restrict themselves to medical concerns; time and again, the language they used to characterize the region evokes its qualities in quite different terms, viewing it as a rural idyll or an earthly paradise. One of the first of these writers, J. Henry Bennet, began his account by invoking his memories of a chorus of fishermen in an opera by Esprit Auber, insisting that such echoes were "fully verified by the realities of everyday experience"; for him, the olive groves evoked the Garden of the Hesperides.[2] Likewise, books whose principal focus was the history of the region often adopted an evocative and metaphorical language; for Charles Lenthéric, the lavish flora of the coast were a "natural fairyland whose regal splendor

no words can convey," and the whole coastline was a "promised land."[3] The Riviera coast received its most poetic evocation in 1887 in a lavishly illustrated volume whose title seems to have marked the first use of the name by which the coastline is so well known today: Stephen Liégeard's *La Côte d'Azur*. The tone of these responses shows how readily visitors to the Riviera could call on cultural stereotypes or clichés to make sense of their experiences there. Indeed, the same chain of mythological associations could be deployed with-

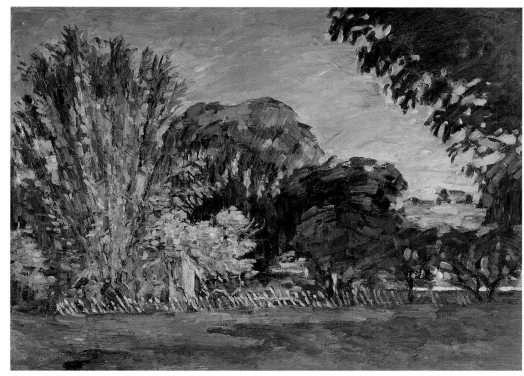

Fig. 6 Paul Cézanne, *Arbres au Jas de Bouffan (Trees in the Jas de Bouffan)*, circa 1875–76, oil on canvas, 21 3/8 x 28 7/8 in., Scott M. Black Collection.

out any reference to particular sites. Auguste Renoir, late in his life, after he had gone to live on the Riviera, in part for health reasons, commented: "In this marvelous country, it seems as if misfortune cannot befall one; one is cosseted by the atmosphere."[4]

Commentators on the South could readily shift their focus between the physical qualities of the environment and the associational and cultural values for which it stood. When we explore the work of the painters of the region, we find the same preoccupations. At first sight, their prime concerns were pictorial—how to express in paint the effect of the southern light. But often the language they used to describe the light was metaphorical in tone; and many of them, in addition to their work as landscapists, also engaged directly with the cultural associations of the region, by painting Arcadian or pastoral themes.

For tourists and painters alike, access to the South had been opened by the railway, but at the same time the landscapist was determined to distinguish his vision from that of the tourist.[5] Even medical travel books recognized that the controlled environment of the train and the health resort excluded the visitor from the

region's greatest beauties. In 1872 Alexander Brown advised "the healthy tourist or the artist . . . to shun the rail" and travel along the coast via the Corniche road:

Impressed by the natural loveliness and fine historical associations embraced in those few leagues of travel, one feels tempted to indulge a moment's weakness, to cast aside all progress and the centuries, and in fancy traverse the bewitching scenery at a pace more gratifying to sentiment and art appreciation. . . . Staff in hand, or seated comfortably *en voiture*, the highway is to be preferred, as no amount of speed repays the loss of the many charming coast and mountain views to be met with.[6]

Charles Garnier, the celebrated architect of the Paris Opéra, who lived at Bordighera, published a guide to the area entitled *Artistic Features of Bordighera*, offering his own detailed local knowledge as an aid to the search for the most picturesque sites. By guiding tourists off the beaten track, he encouraged them to penetrate the depths of the countryside, leading them through overgrown paths to remote ravines.[7] Claude Monet may well have followed some of Garnier's suggestions at Bordighera in 1884; his viewpoint in *Bordighera* (fig. 2), over the old

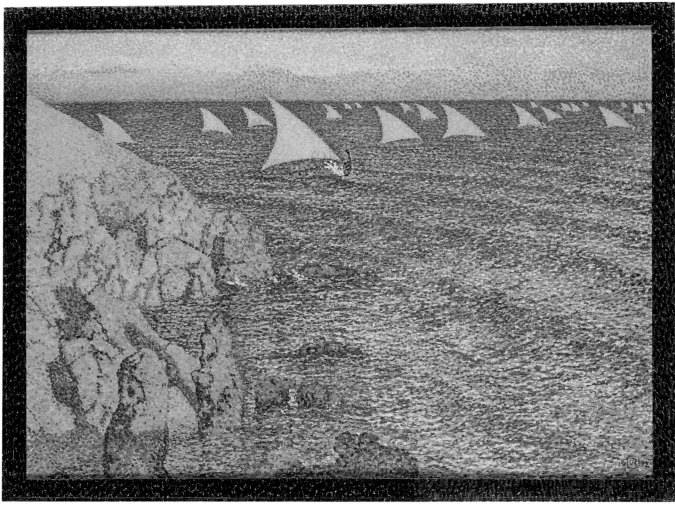

Fig. 7 Théodore van Rysselberghe, *La Régate (The Regatta)*, 1892, oil on canvas with painted wood liner, 23 7/8 x 31 3/4 in., Scott M. Black Collection.

town with the church tower silhouetted between two spectacularly contorted tree trunks, shows the fruits of his explorations of the place's wooded hillsides. In 1888 at Antibes, we find him dismissing the advice of other artists, but at the same time he chose many of the most popular sites in the region.[8]

On their first visit to the South, artists were immediately struck by the unfamiliar quality of the light—by its dazzling luminosity and also by the vividness of the colors under certain conditions. We have many records of their initial sense of shock, and of the immediate problems they faced in trying to convey its effects. At first sight, this was a question of naturalism: what was the Mediterranean light really like, and how might it be translated into paint? But, faced with its intensity, artists were forced to acknowledge one of the fundamental

principles of painting—the simple incapacity of colored paint to replicate the effect of sunlight. The challenge posed by the southern light was perhaps the single factor that brought home most clearly to artists the impossibility of any straightforward notion of naturalism in art. As Paul Cézanne put it, late in his life: "I wanted to copy nature, but I didn't succeed. But I was content with myself when I discovered that sunlight cannot be *reproduced*, but that it must be *represented* by something else."[9]

The painter cannot equal the light of the sun, in the sense of actually matching it, but must seek some equivalent for its effect, within the artificial confines of a two-dimensional rectangle. This immediately introduces issues of a quite different type: what pictorial devices and conventions can most effectively evoke the effects of sunlight? The history of nineteenth-century and early-

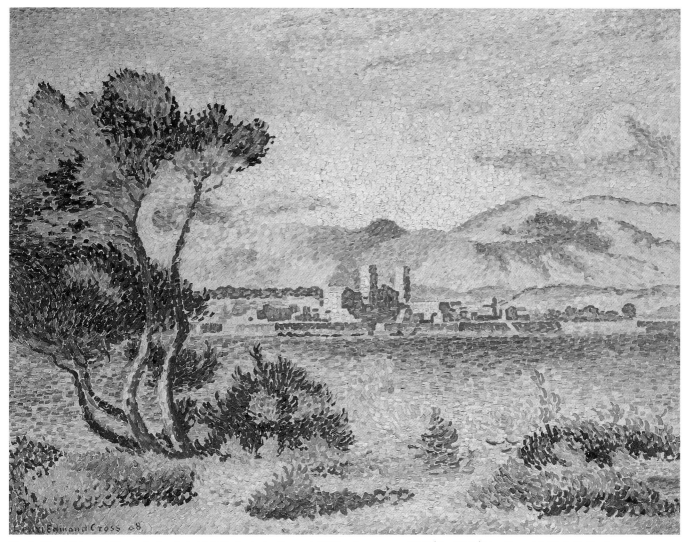

Fig. 8 Henri Edmond Cross, *Antibes, Après-Midi (Antibes in the Afternoon)*, 1908, oil on canvas, 31 7/8 x 39 3/8 in., Scott M. Black Collection.

twentieth-century attempts to paint the southern light is the story of the various devices and conventions the painters explored.

Three distinct approaches were adopted, and used in various combinations, throughout the period: a tonal or chiaroscural mode; a colorist mode; and a mode that stressed luminosity, often described as *peinture claire*. The first two were described by Eugène Fromentin in 1858, contrasting the approaches of Alexandre Decamps and Eugène Delacroix to the problems of rendering the light of North Africa (it was widely agreed that this posed problems very much the same as the Riviera):

In the Orient, [Decamps] saw the "effect": the crisp, harsh opposition between shadow and light. Unable directly to capture the sunlight, which burns the hands of all who seek it, he made a very clever detour: given the impossibility of expressing much sunlight with few shadows, he thought that with much shadow he might succeed in producing a little sunlight, and he has succeeded. . . . [Delacroix] in turn also made an abstraction out of color. He so aggrandized its role and gave it such importance . . . that he made us believe—quite wrongly—that he scorned form or was ignorant of it.

Delacroix achieved his effects, Fromentin continued, not by seeking to capture the actual effects of light and shade in North Africa, but through emphasizing "the magnificent sonority of his colorations."[10] Fromentin's

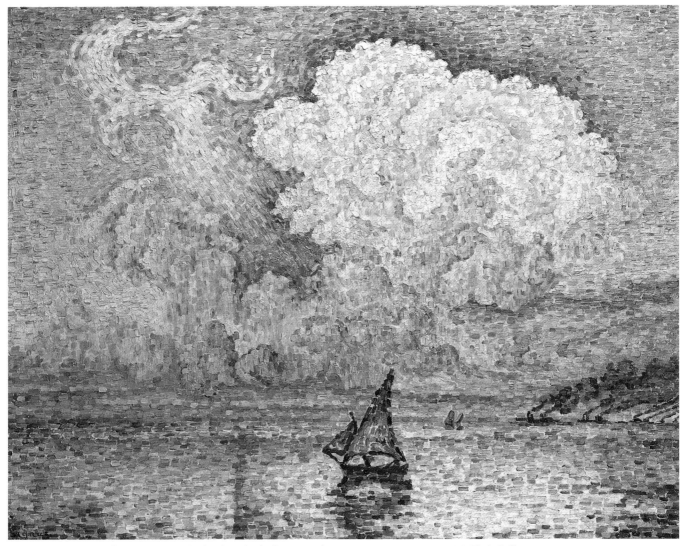

Fig. 9 Paul Signac, *Antibes, Le Nuage Rose (Antibes, the Pink Cloud)*, 1916, oil on canvas, 28 x 35 in., Scott M. Black Collection.

account is all the more significant because he insisted that this was not a question of different types of naturalism, but rather of artistic devices deployed to achieve pictorial effects.

The third mode was described by Théophile Gautier in 1857, in seeking to justify the way in which Jean-Léon Gérôme represented the Sahara desert; here, in contrast to Fromentin, the explanation is couched in terms of naturalism:

> People normally represent the hot countries in a flamboyant and torrid manner; that is true sometimes but not always. With its all-pervasive whiteness, the extreme light decolors the sky, land, and fabrics. The burning sand under the leaden sun takes on the chill appearance of snow; the intangible dust, on the horizon, forms a type of fog that cools the colors and extinguishes them. Hence, the absolute truthfulness of the *Egyptian Recruits Crossing the Desert* astonishes viewers' eyes more than it convinces them.[11]

These three modes of suggesting the southern light were nothing new in the history of art. Decamps looked to past artists in the chiaroscural tradition, notably Rembrandt, and Delacroix to colorists such as Veronese and Rubens. *Peinture claire*, too, had a long ancestry, through landscapists such as Van Goyen and Guardi, and down to Valenciennes, Corot, and Boudin. Valenciennes and Corot, especially in their oil sketches of Italy, at times combined *peinture claire* with rich color contrasts;

Boudin's *peinture claire* was evolved to convey the light effects of France's northern coasts.[12] Local landscapists working in the South in the mid-nineteenth century also explored both color and *peinture claire;* Emile Loubon, the pioneer landscapist of the Mediterranean coast, working around Marseille in the 1840s and 1850s, favored light-toned, luminous tonalities, though at times combined with intense color, while in the 1860s Paul Guigou often used a range of intense colors.[13] In the 1880s, too, southern landscapists exhibiting at the Paris Salon adopted both modes—Frédéric Montenard favoring high-key color, whereas Alfred Casile used a more subdued but luminous palette.[14]

Impressionist landscape painting, as it emerged in northern France in the early 1870s, also achieved its effects through combinations of color painting and *peinture claire.* Monet's and Renoir's later experiences of painting in the South did not transform their approach to color and light; rather, it forced them to refine their previous practices. The example of Cézanne was significant here. Born and brought up in the South, at Aix-en-Provence, he had early experience of painting the southern light, and from the late 1860s onward was already organizing entire compositions around contrasts of warm and cool colors (e.g., *The Railway,* c. 1869, Bayerische Staatsgemäldesammlungen, Munich). In 1876, after his experience of painting alongside Camille Pissarro in the North, Cézanne defined the distinctive problems that he faced in painting the South: "It's like a playing card, red roofs over the blue sea. . . . The sun here is so tremendous that it seems to me as if the objects are silhouetted not only in black and white, but also in blue, red, brown, and violet. I may be mistaken, but this seems to me to be the opposite of tonal modeling."[15] Again, the problem is described in terms of naturalism, but the solution is proposed in pictorial terms—in terms of contrasts and nuances of colored paint. In the picture described, *L'Estaque,*[16] intense orange-reds stand out boldly against the rich blue sea; likewise, in *Arbres au Jas de Bouffan (Trees in the Jas de Bouffan)* (fig. 6), painted about the same date, the whole

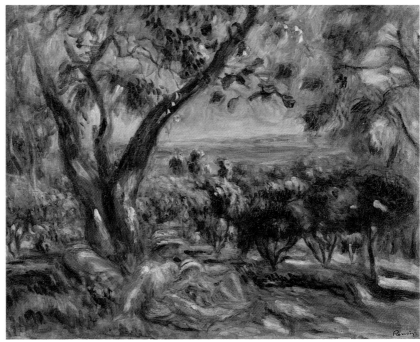

Fig. 10 Pierre-Auguste Renoir, *Landscape at Cagnes,* 1910, oil on canvas, 21 3/8 x 25 3/4 in., The Toledo Museum of Art. Gift of Mrs. C. Lockhart McKelvy, 1962.1.

composition is brought to life by the succession of vibrant red accents among the foliage across the middle ground.

Cézanne's friend the landscapist Antoine Guillemet, who visited him at Aix during the same summer, articulated the problems in much the same way but reached very different conclusions: "The true Midi is really not made for painting, and particularly not for landscape. Green and blue are enemies that are too irreconcilable, and both abound in the valley of Aix. There is too much sunlight, too much light everywhere, which deprives the scene of charms which are essential for a work of art. Everything is so intensely illuminated that there are no longer any contrasts." Guillemet's art, grounded in tonal contrasts, found no way to translate this new range of effects.[17] By contrast, Renoir and Monet did not shirk the challenge.

Renoir's first experience of the Mediterranean was in Algeria in 1881; he later remembered: "In Algeria I discovered the value of white. Everything is white—the burnouses they wear, the walls, the minarets, the road . . . and against this the green of the orange trees and the gray of the fig trees."[18] White plays a central role in most of Renoir's Algerian canvases, but, in some of his

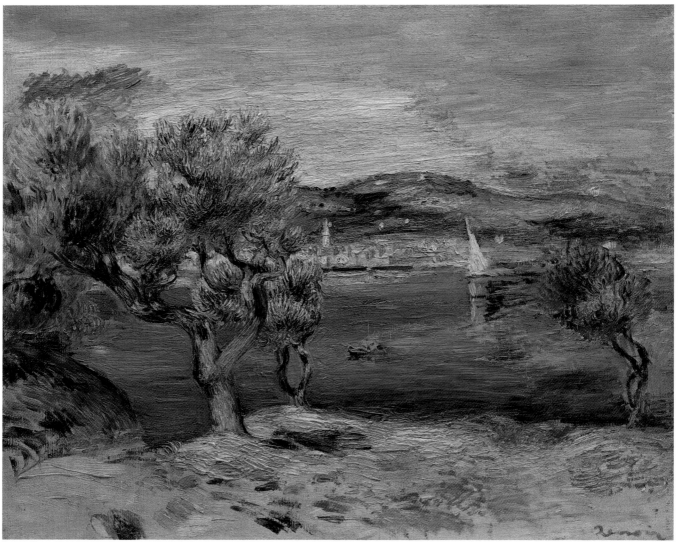

Fig. 11 Pierre-Auguste Renoir, *L'Estaque,* circa 1890, oil on canvas, 18 3/8 x 21 7/8 in., Portland Museum of Art, Maine. Gift of Mr. and Mrs. A. Varick Stout in memory of Mr. and Mrs. Phineas W. Sprague, 1975.451.

views of sites on the French Mediterranean coast painted later in the 1880s, such as *L'Estaque* (fig. 11), probably executed about 1890, the prime emphasis is on strong contrasts of reds and oranges set against blues and greens. His later views of the coast combine rich color with an overall luminosity (see, e.g., back and front covers).

When he began to paint at Bordighera in 1884, Monet at once realized that the light presented him with a novel experience: "It's terribly difficult; one would need a palette of diamonds and precious stones." A month later, he was able to examine the problems more clearly: "[My work] may well make the enemies of blue and rose complain, since it is precisely that bril-

liance, that magical light that I am trying to render, and those who have never seen this countryside, or who haven't looked at it properly, will protest, I'm sure, that it is unrealistic, though I am well below the tone; everything here is pigeon's breast and punch flame."[19] Contrasts of luminous blues and orange-pinks—"pigeon's breast and punch flame"—play a central part in most of Monet's southern canvases and predominate in pictures such as *Cap Martin, near Menton* (fig. 5), *Monte Carlo seen from Roquebrune* (fig. 1), and *The Mediterranean (Cap d'Antibes)* (fig. 4); in his art from this point onward there was a clearer overall sense of orchestration—of harmonization—in his color schemes. Yet a picture such as *Bordighera* (fig. 2) shows how complex his solutions

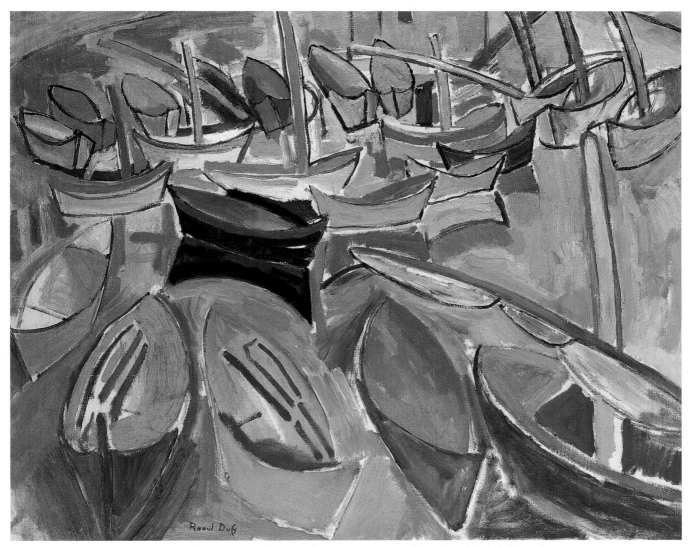

Fig. 12 Raoul Dufy, *Barques aux Martigues (Boats in Martigues)*, 1907, oil on canvas, 25 x 31 3/4 in., Scott M. Black Collection.

were. The blue-orange contrasts are set off against the rich greens of the foliage; but the picture is also given a tonal structure—pivoting around the luminous town in the distance and anchored at bottom right by the pool of deep shadow; this is full of varied color but still acts as a dark zone, in contrast to the brightness and luminosity of the rest. The colored shadows on the curling tree trunks lend further structure to the composition.

The problems of painting the southern light were most clearly articulated by the Neo-Impressionist Paul Signac, Georges Seurat's closest associate, who first visited the Mediterranean in 1887 and established his home at Saint-Tropez in 1892. Signac's paintings and writings show him seeking to reconcile the luminous and the col-

ored versions of the South. Initially—like Cézanne and Monet—he sought naturalistic justifications for his position, but increasingly, in the 1890s, he came to see the pictorial effect as an end in itself that did not need such justification.

After his first visit to the South, to Collioure, at the western end of the French Mediterranean coast, near the Spanish border, he wrote: "One is astonished not to see here the accentuated blues that ordinary painters of southern landscapes are so proud of. These men fail to see that the orange light of the sun, reflected everywhere, decolors the shadows, tones down the local colors, and pales the purest skies."[20] Montenard was one of the focuses of his criticism, but he might well have

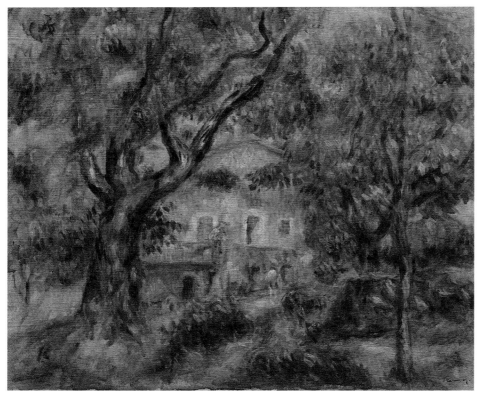

Fig. 13 Pierre-Auguste Renoir, *The Farm at Les Collettes, Cagnes*, circa 1914, oil on canvas, 21 1/2 x 25 3/4 in., The Metropolitan Museum of Art. Bequest of Charlotte Gina Abrams, in memory of her husband,

terms that Gautier had used in 1857 to justify Gérôme's treatment of the desert light:

"I think that I have never painted pictures as 'objectively exact' as those from Cassis. There is nothing but white there. The light reflected everywhere consumes all the local colors and turns the shadows gray. Van Gogh's paintings of Arles are marvelous in their fury and intensity, but they wholly fail to capture the 'luminosity' of the South. Just because they are in the South, people expect to see red, blue, green, and yellow. On the contrary, it is the North—Holland, for example—that is 'colored' (local colors), while the South is 'luminous.' "[23]

Despite his criticisms of Van Gogh's intense color, Signac's own art, and that of his friends and associates Henri-Edmond Cross and Theo Van Rysselberghe, was moving in a similar direction; in Van Rysselberghe's *Régate (The Regatta)* (fig. 7) the rich color contrasts even extend across the painted frame. In 1895 Signac wrote in his journal about Cross's latest work: "It is a most successful attempt at heightening color to the extreme. That is something we would not have dared to do a few years ago, when we were . . . spreading light across all parts of the canvas. In this painting by Cross, the effect is very successful thanks to the suppression of the light in favor of the coloration of the sea."[24] In 1907 Maurice Denis, reviewing Cross's work, spelled out the direction that his and Signac's art had taken over the past fifteen years (figs. 8, 9, cat. 15):

Twenty years ago, with as much enthusiasm as any of us, Cross was trying to create sunlight. . . . Now, however, having looked a lot and reflected a lot . . . he is more and more substituting the play of color for the play of light. . . . Cross does his utmost to imagine harmonies equivalent to sunlight, and to institute a style of pure color. . . . Cross has resolved to represent the sun, not by bleaching his colors, but

included some of Monet's southern canvases in his strictures. However, Signac was also alert to the issue of intense color, as he showed in a letter written to Vincent van Gogh in 1889 on his next southern trip, describing the scenery at Cassis: "White, blue and orange, harmoniously spread over the beautiful rise and fall of the land. . . . Our malachite green and cobalt blue are as dung beside the Mediterranean waves."[21] His paintings from Collioure and Cassis are generally very blond in tonality, though with a rich and varied combination of soft "points" of color.[22] In certain parts in the pictures, the colors are more intense; in the Cassis canvases, they are accentuated especially along lines of demarcation between warm and cool zones, thus creating pivotal points of strong contrast amid the overall luminosity. Edvard Munch, painting *The Beach at Nice* in 1892 (fig. 14), used a similar combination of light tones and accentuated color contrasts, though using loose, fluid brushwork quite unlike Signac's.

Five years later, in 1894, Signac, looking back to his experiences at Cassis, described them in much the same

by exalting them, and by the boldness of his color contrasts. . . . The sun for him is not a phenomenon that makes everything white, but is a source of harmonies that hots up nature's colors, authorizes the most heightened color scale, and provides the subjects for all sorts of color fantasies.[25]

In this context, we can return to Cézanne's comments about the impossibility of reproducing sunlight and the need to represent it by something else, for he made it clear to Denis what this "something else" was:

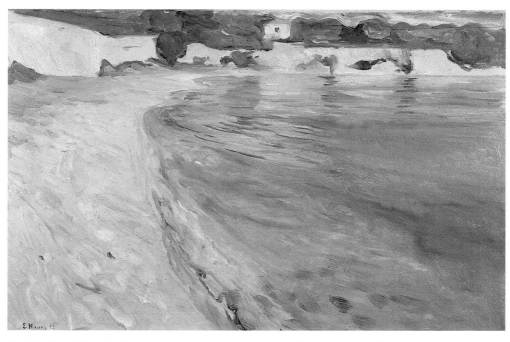

Fig. 14 Edvard Munch, *The Beach at Nice*, 1892, oil on canvas, 18 1/4 x 27 in., Munch Museum, Oslo, M 1076.

color.[26] In these terms, his approach to painting the southern light developed along lines parallel to those taken by Signac and Cross; his late southern landscapes, like theirs, show contrasts and rhymes of rich color repeated across the whole canvas. Yet in a crucial way his practice was different from theirs; like them, as he explained in an interview with Emile Bernard published in 1904, he viewed the whole canvas as an integrated harmony, achieved by "contrasts and relationships of hues"; but he sought to organize his compositions around "dominant touches" to "unify and concentrate" the picture.[27] In many of his late works, an accent of accentuated color, usually vivid red or orange, acts as the pivot around which the rest of the color composition is organized.

The final stage in the debates about southern color came in 1904–6, in the work of Matisse, Derain, and their associates. In 1904 Matisse had worked with Signac at Saint-Tropez, a stay that resulted in *Luxe, calme et volupté* (Musée d'Orsay, Paris), an elaborate figure composition executed in a Neo-Impressionist technique very like that of Signac and Cross. In the summer of 1905 he painted with Derain at Collioure: their experiences there forced both men to rethink their technique and their use of color. Derain defined the two key lessons

that his experiences were teaching him:

1. A new conception of light that consists in this: the negation of shadow. Here, the light is very strong and the shadows very luminous. The shadow is a whole world of brightness and luminosity in contrast to the light of the sun: this is what one calls reflections. . . .
2. In Matisse's company, to work out how to eliminate the division of tones. He continues with it, but I have completely given it up and scarcely ever use it. It is logical in a tapestry or in a luminous and harmonious panel. But it harms things that gain their expression from deliberate disharmonies.[28]

Matisse, too, quickly abandoned the harmonies of Neo-Impressionism in favor of "deliberate disharmonies" like Derain's. Looking back at this phase of his career, he remembered:

At Saint-Tropez I met Signac and Cross, theoreticians of Divisionism. . . . All the paintings of this school had the same effect: a little pink, a little blue, a little green; a very limited palette with which I didn't feel very comfortable. Cross told me that I wouldn't stick to this theory, but without telling me why. Later I understood. My dominant colors, which were supposed to be supported by contrasts, were eaten away by these contrasts, which I made as

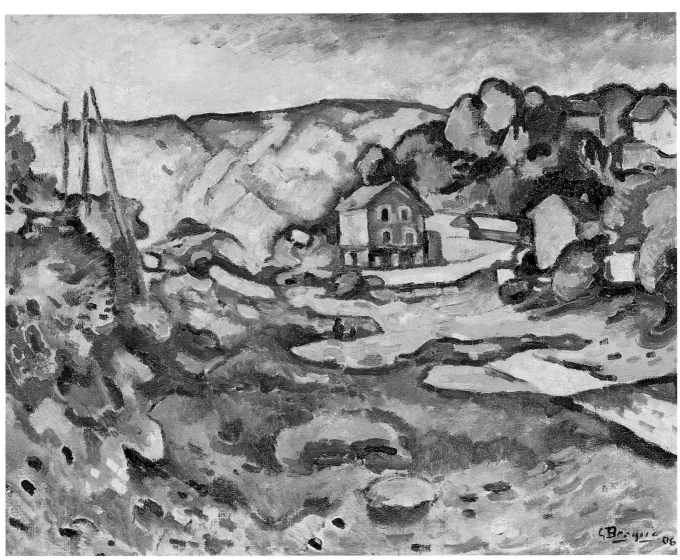

Fig. 15 Georges Braque, *Landscape, L'Estaque*, autumn 1906, oil on canvas, 20 x 23 3/4 in., New Orleans Museum of Art. Bequest of Victor K. Kiam, 77.284.

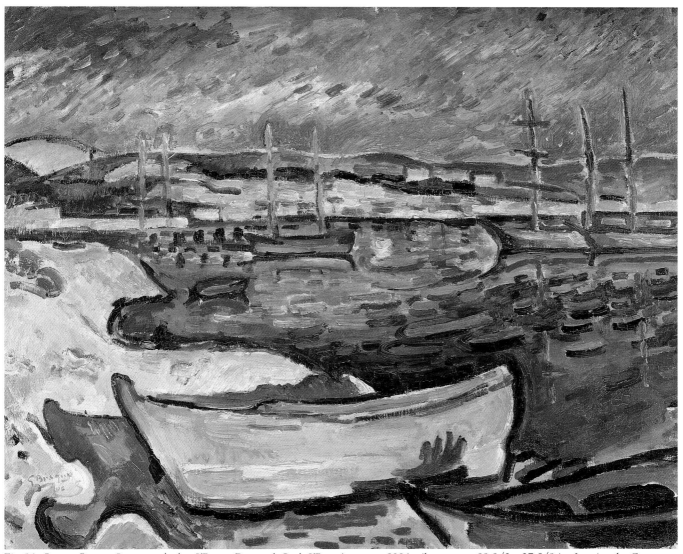

Fig. 16 Georges Braque, *Bateaux sur la plage, L'Estaque (Boats on the Beach, L'Estaque)*, autumn 1906, oil on canvas, 19 1/2 x 27 5/8 in., Los Angeles County Museum of Art. Gift of Anatole Litvak, 53.55.1.

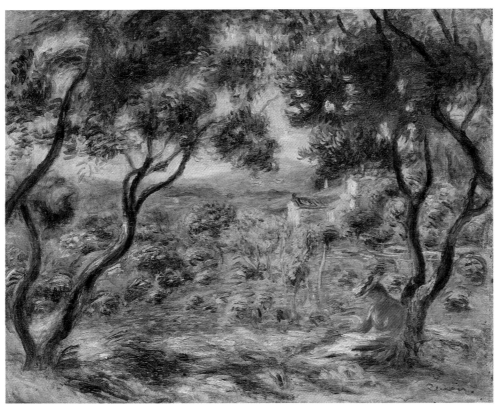

Fig. 17 Pierre-Auguste Renoir, *Les Vignes à Cagnes (Vines in Cagnes)*, 1906, oil on canvas, 18 1/4 x 21 3/4 in., Brooklyn Museum of Art. Gift of Colonel and Mrs. E. W. Garbisch, 51.219.

the depiction of southern light may appear like a linear narrative, leading toward ever greater emphasis on pure and contrasting color. Yet all the cases that we have examined are more complex than this; tonal anchoring remained important for Monet and Cézanne, whiteness and dazzle for even the most intense colorists, and, even after the initial outburst of Fauvism, the luminous, subdued alternative was still available. Before World War I, Albert Marquet had painted in the North; it was then that he was closest to the Fauves and then that his color was brightest; after the war, he traveled extensively in the South. Monet bought one of his southern canvases but without realizing what site it showed: "Ever since I was told that it was the South, it has really put me off; I had taken that tender grisaille for Brittany."[32]

The painters' experiments with tone and color in the South demonstrate that the idea of naturalism in painting, taken literally, is inconceivable. We have explored a sequence of painters discovering this for themselves, in the most difficult circumstances, in face of the unpaintable, and have analyzed their efforts to work out pictorial equivalents to the intensity of their visual experiences.

For the painters we have examined, color and light conveyed the essence of the South; few of them, though, painted the people who lived and worked there. For many, the physical presence of the local peasant was a distraction—an obstruction even—to their image of the region. Garnier, in *Artistic Features of Bordighera*, repeatedly lamented the recent changes that had taken place in his beloved landscape: "the peasant all the world over has ever been found without artistic sympathies of any kind."[33] Garnier found the true meaning of the place in

important as the dominants. This led me to painting with flat tones: it was Fauvism.[29]

Signac had bought *Luxe, calme et volupté* from Matisse, but when he saw his next major figure painting, *Bonheur de vivre* (Barnes Foundation, Merion, Pa.), he was horrified: "he has surrounded strange silhouettes with a line as broad as your thumb. And then he has covered the whole thing with flat, smooth colors, which, though they are pure colors, make one feel sick.... It looks like . . . the most detestable cloisonnism."[30]

The intense color of Matisse and Derain, juxtaposed in unexpected combinations and in zones of varied size, greatly influenced the works that his friends Georges Braque, Raoul Dufy, and Emile-Othon Friesz executed in the South during the next two years (figs. 12, 15, 16, cat. 21); only in Braque's *Landscape, L'Estaque*, painted in the autumn of 1906, do we see the beginnings of new developments, with the introduction of a greater sense of structure, reminiscent of Cézanne, to a composition dominated by high-key Fauve colour.[31]

Presented in this way, this account of debates about

its evocations of Italy and Greece and especially of the biblical landscapes of Palestine. Most visitors to the Riviera found similar associations there. For Félix Ziem, the landscape around Martigues, to the west of Marseille, "yields nothing to Greece," as he wrote in 1860, seeking to entice Théodore Rousseau to leave his beloved Forest of Fontainebleau and come to paint with him in the South.[34] Signac, on his first visit to Saint-Tropez in 1892, was immediately reminded of Naples and Capri.[35]

Comparisons such as these cannot be taken literally; rather, they belong to a network of cultural stereotypes that link ideas of classicism and the antique, the Arcadian idyll and the pastoral, the earthly paradise and the golden age. Although the actual history of the Riviera might be invoked, the associations were fundamentally metaphorical; and the region's history itself might be treated in an allegorical rather than documentary mode, as in Puvis de Chavannes's decorations of 1869 for the Musée des Beaux-Arts in Marseille, *Marseille colonie grecque* and *Marseille porte de l'Orient.*[36]

These associations were a part of the collective cultural consciousness of late-nineteenth-century France. The insistence that France itself embodied a living part of classical antiquity was a potent myth, and one that could be deployed for both radical and conservative political agendas. In 1894–95 Signac sited his anarchist idyll *In the Time of Harmony* (Mairie de Montreuil, Paris) in a landscape derived from the coastline at Saint-Tropez, while Denis, increasingly allied to the political right after 1900, created idyllic tableaux of figures on southern beaches—sometimes ostensibly contemporary, but often overtly mythological.[37]

The most overt attack on the imagery of the southern peasant came about 1905 from Cross, like Signac a sympathizer with anarchist politics: "A long time ago I discovered my insensitivity towards the peasant. I find him here [in the South] especially without plastic interest, and I would not know how to paint him. . . . On the rocks, on the sand of the beaches, nymphs and naiads appear to me, a whole world born of beautiful light. These beautiful forms have circulated in my vision for too long for me not to attempt to render them perceptible in painting."[38] Many of Cross's later works are seemingly timeless idylls of nude or seminude female figures on southern beaches; Matisse's *Luxe, calme et volupté,* with

its title taken from Baudelaire's poem "Invitation au voyage," uses comparable imagery, and his *Bonheur de vivre,* despite its very different technique, belongs to this genre of classicizing pastorals. From a different standpoint, Renoir, near the end of his life, conjured up a similar vision of the South, both in his scenes of female bathers in radiant sunlit settings and in smaller landscapes such as *Les Vignes à Cagnes (Vines in Cagnes)* (fig. 17; see also figs. 10 and 13), with its little seated figure framed by trees reminiscent of the ideal landscapes of Claude Lorrain. At the end of his life, Renoir commented to the Provençal poet Joachim Gasquet: "What admirable beings the Greeks were. Their existence was so happy that they imagined that the Gods came down to earth to find their paradise and to make love. Yes, the earth was the paradise of the Gods. . . . That is what I want to paint."[39]

When Signac began to live at Saint-Tropez in 1892, the place was still unspoiled—protected by its location from the ribbon development that was already ruining much of the Riviera coast. In 1956 Roger Vadim's film *And God Created Woman,* set at Saint-Tropez, created an immediate sensation. In it, two stories run in parallel. In one, a rich and unscrupulous property developer seeks to buy a failing old-fashioned boatyard to build a casino and thus wreck the last remnants of "old" Saint-Tropez; in the other, a local young woman, embodied in Brigitte Bardot, seeks emotional and sexual fulfillment, torn between the "old" world of the men who run the boatyard and the lure of "new" wealth. She is presented as a product of nature, not culture; yet she is a "new" woman in her sexual liberation, the enemy of the strait-laced moral codes of the "old" town. At the film's apocalyptic moment, she is cast up on the beach, a modern-life incarnation of the birth of Venus, the classical goddess of love, from the waves.

The film's two plots are not separate; Bardot represents both past and future and embodies the coastline itself. Likewise, the various facets of the social and artistic history of the Riviera coast that we have explored are all part of a single story: about the relationship between imaginative travel and actual tourism; about the artist's exploration of the artistic vision and the limits of naturalism; and about the role of myth in making sense of novel forms of experience.

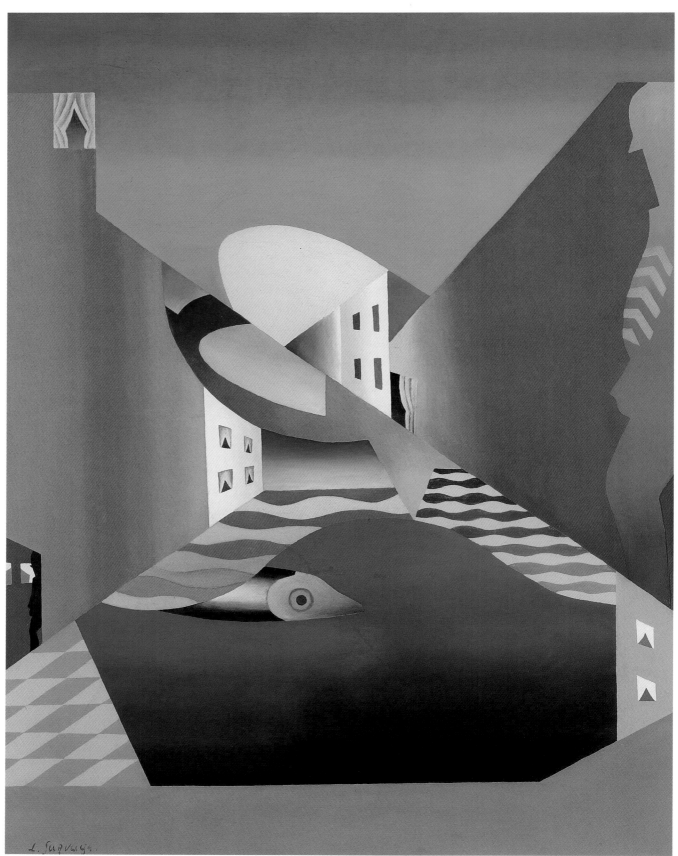

Fig. 18 Léopold Survage, *Nice*, circa 1916, oil on canvas, 36 1/4 x 29 in., Private collection.

MONTPARNASSE HEADS SOUTH

ARCHIPENKO, MODIGLIANI, MATISSE, AND WWI NICE

KENNETH WAYNE

The creative energy and activity that characterized Montparnasse at the beginning of the century did not dissipate with the outbreak of war on August I, 1914. Rather, it continued largely unabated in a new place, Nice, where many Montparnasse figures moved to find peace and quiet. Far from the front, sunny Nice continued to offer its residents and visitors a relatively carefree life: the casino, luxury hotels, and movie houses still operated on a limited basis, tourist cafés along the Promenade des Anglais remained open, charity benefits were held, operas were performed, an international tennis tournament took place, and tourism to the area was encouraged. "Nice is still Nice!" declared one local newspaper on October 15, 1914. "The charm of the Riviera, even during war, has not been lost."[1] The years of war in Nice proved to be a turning point both in the artistic history of the region and in the careers of several of the artists and writers who congregated there.

Among the Montparnasse artists who relocated to the Nice area during the war were: Alexander Archipenko, Serge Férat and his sister the Baroness d'Oettingen, Léonard Foujita, Henri Matisse, Amedeo Modigliani, the American Synchromist painter Morgan Russell, Chaim Soutine, and Léopold Survage. Auguste Renoir, the grand old man of the avant-garde, had been visiting the area for years before buying the estate "Les Collettes" in Cagnes in 1907 and living there year-round.[2] His presence validated the area as a worthy place for artistic activity. Also nearby at the time were Paul Signac, who painted in Saint-Tropez and Antibes; Pierre Bonnard, who worked in Cannes; and Moise Kisling, who also was in Saint-Tropez. The art dealers Paul Durand-Ruel, Paul Guillaume, Ambroise Vollard, and Léopold Zborowski visited the area as well. Raymond Duchamp-Villon made his last important sculpture, *Portrait of Professor Gosset* (Philadelphia Museum

of Art), in a military hospital in Cannes, where he died in October 1918.

Among the Montparnasse literary figures with close ties to artists who contributed to the creative mix in Nice were Guillaume Apollinaire, Blaise Cendrars, and Jules Romains. It was in the Nice area in 1917–18 that Cendrars worked on his two famous war-related works: *J'ai tué* and *Profond aujourd'hui.*[3] Romains's biographer André Bourin wrote that "after Paris, no other town was as lovingly described by Romains as Nice."[4] The Belgian writers Maurice Maeterlinck (the Nobel prize winner for literature in 1911 whose early plays took Symbolism into the theater) and Franz Hellens (whose dreamy writings prefigure Surrealist literature) also spent much time in Nice.

Of the literary figures, Apollinaire deserves extended discussion, for his ties to the area were especially strong.[5] Raised on the Riviera and schooled in Monte Carlo, Cannes, and Nice, he returned on several occasions. When war broke out, he traveled to Nice to be with friends, and it was there that he enlisted in the French army, actually, given his Polish nationality, the Foreign Legion. It was also in Nice that he met one of the great loves of his life, the Countess Louise de Coligny-Châtillon, whom he affectionately called "Lou." His numerous letters to her, published as *Lettres à Lou*, are filled with references to Nice. This volume contains many of the artist's famous visual poems—his *calligrammes*—including one that he called "bien Niçois," which depicts a pear, an eyelet, and an opium pipe.[6] Apollinaire's other wartime writings also make reference to Nice.[7]

Nice had become an important center for movie making. Both the Pathé and Gaumont movie companies opened studios there, Pathé in 1910 and Gaumont in 1913. Cendrars was immersed in film. He worked with the director Abel Gance (see fig. 44) on *J'accuse* and

Fig. 19 Archipenko's identity card in Nice, Alexander Archipenko Papers, roll NA9, frame 12, Archives of American Art, Smithsonian Institution, Washington, D.C.

Fig. 20 Château Valrose, Nice (photo taken July 1997). It is now the administration building of the Université de Nice.

other films and for other projects tried to enlist the collaboration of Apollinaire, Romains, Jean Cocteau, Picasso, Russell, and even Charlie Chaplin.[8] Cendrars's cinematic experiences in Nice informed his essay "L'ABC du cinéma," begun in 1917 and completed in 1921.[9]

Like Montparnasse, Nice was intimate in size. More important, Nice was also remarkably cosmopolitan, with large communities of Englishmen (who were responsible for the construction of the Promenade des Anglais, Nice's famous boardwalk), Russians, and Italians, not to mention the multinational group of artists mentioned above. If Montparnasse was "the first truly international colony of artists we ever had," as Marcel Duchamp put it,[10] then Nice was surely the second. Whereas Montparnasse had the famous intersection carrefour Vavin as its center of activity, Nice had the rue de France, on or near which many of the artists discussed here lived. For three major artists in particular—Archipenko, Modigliani, and Matisse—this was a crucial period for their art. Each benefited from artistic

contacts in this new community, and each became deeply interested in representing light.

The artist who thrived the most in wartime Nice was the Ukrainian Alexander Archipenko, a Russian national (fig. 25). He spent the entire period there, arriving by October 27, 1914,[11] and remaining into 1919 (fig. 19). He was exempt from military duty because of an impaired leg.[12] Archipenko may have chosen Nice as a wartime destination because of the large and entrenched Russian community there, which dated to the middle of the nineteenth century. Russian aristocrats played as large a role as English aristocrats did in the development of Nice as a fashionable destination in the nineteenth century.[13] One of these was baron von Derweis, who built the Château Valrose in 1865–67 (fig. 20).[14] Archipenko worked at the Château Valrose, where he made the important sculpto-painting *Before the Mirror (In the Boudoir)* of 1915 (fig. 23).[15] In the period just before 1917, there were also many Russian revolutionaries in Nice, such as Boris Savinkov, and Archipenko was very much involved in this milieu.[16]

28

Fig. 21 Postcard of the Nice train station sent by Blaise Cendrars in Nice to Morgan Russell in Cannes, postmarked February 12, 1918, Morgan Russell Archives, Collection of the Montclair Art Museum, New Jersey.

Although Archipenko had experimented with Cubist principles before the war, during his time in Nice he fully developed his most important contributions to modern sculpture. His use of voids and concave and convex elements introduced to sculpture the Cubist notion of the equivalence of space and mass. The artist's residence in Nice and his friendships there conditioned these developments. It is important to note these facts, for this five-year period is often considered in the literature as part of his Paris experience. Archipenko's immediate environment had always had a decisive influence on the works he created, and Nice was no exception.

We see voids and concave/convex elements at play in three of Archipenko's most famous statuettes: *Woman Combing Her Hair, Seated Woman Combing Her Hair,* and *Standing Figure* (figs. 22, 24, 27), all of which were made in Nice. One is made more aware of mass by dint of its absence. These elements help fulfill the Cubist aim of breaking down the barrier between an object and its environment. "Negative" space surrounding the work thus becomes positive space, that is, an active element in the sculpture. This concept was to be of seminal importance to twentieth-century sculptors; it is easy to see, for example, how crucial it was to Alexander Calder and his mobiles. Similarly, because concave areas reflect light, this empty space becomes "positive" space. If one changes one's position and/or that of the light source, shadows and light alternate. Once again, object and surroundings interact.

If the bright white ceramic of *Standing Figure* evokes the sunshine of the coast, the green patina on the other figures recalls the Mediterranean Sea. These figures are slim and curvaceous, whereas Archipenko's prewar Parisian figures, despite their dynamism, seem clumsy and awkward by comparison. The sensuality of the Niçois figures contributes to their Cubism, as sexy, side-swung hips accentuate the play of geometric forms with curves alternating with sharp angles. These figures depart from the prewar Parisian works in another way, their subject matter. Bathers and nudes have replaced circus performers, dancers, and boxers.

Although the date found on examples of Archipenko's famous work *Flat Torso* (fig. 26) is variously 1914 and 1915, it was undoubtedly made on the Riviera, and probably in 1915. In terms of style and subject, the luminous *Flat Torso* is more akin to the classical and elegant Riviera statuettes rather than the dynamic Paris ones. In addition, *Flat Torso* is not among Archipenko's latest works illustrated in the June 1914 issue of the avant-garde periodical *Les Soirées de Paris*, reinforcing the idea that he made it after that date.

Aside from these curvaceous statuettes, Archipenko's other major innovation of the Nice period was his sculpto-painting, an art form that shows increased sophistication over his earlier work. Visual stimulation is created, not by colorfully painted subjects, but by a kaleidoscopic combination of mixed media, varied textures, plays of dimensionality, and an interest in light and color. The barrage of visual stimuli produces a highly unstable, disjointed image that prevents the eye from focusing completely. Sculpto-paintings formed the bulk of Archipenko's production in Nice and were, for the most part, limited to that period. Later, Archipenko called the sculpto-paintings his most important works.[17] Archipenko had made mixed-media constructions before he went to Nice, painting his figures with opaque colors, but they were meant to be seen in the round, whereas the sculpto-paintings were meant to hang on a wall and are more visually jarring. *Before the Mirror* (fig. 23) is an excellent example of his sculpto-paintings, containing a variety of relief elements and textures—tin (meant to function like a mirror), paper, a photograph, wood—

which activate the picture surface. They also help create a picture within a picture. Indeed, were it not for the title, one would not know whether one were looking out a window, at a picture, or through a doorway. The third dimension is represented through three types of reality: painted, photographic, and actual three-dimensional relief elements.

Similar to the statuettes, *Before the Mirror* is a mixture of angular and curving rhythmic elements, which combine to produce a vital Cubist tension. The sharp angles of the bits of tin, the photograph holder, and the collage paper contrast with the sinuous female forms in the center. The former almost appear to devour the latter. Complicating the image further is the treatment of the breasts. In typical Cubist fashion, the beholder is presented with many views: frontal and side, though in this instance they are two separate breasts and not one. The third breast, on the right, is just an outline, whereas the left breast is fully formed and shaded to appear as "real" as possible. The outlined breast is a reminder of the illusionistic nature of painted representations.

Passages of opaque paint are now juxtaposed with translucent ones. This new concentration on translucent paint, on paint as light, is integral to the dynamism and discontinuity of the image, for the figures throb, radiate, and glisten. The eye, therefore, is kept in constant motion. The dominant use of complementaries (blue and orange, red and green) extends the disconcerting effects; colors are not allowed to blend but instead are played against their opposites. The colors also produce ambiguity; the lime green figure has a yellow arm, while the yellow figure has a lime green arm. Or does each just have an arm around the other? Archipenko discussed the use of color in his sculpto-paintings, saying, "[I]t would be ridiculous to unite the forms and the color in the fashion of hairdresser's mannequins, for art is not an imitation of nature."[18]

Competing with the illusionistic light of *Before the Mirror* is real light, which plays an active role because of the reflective materials and the relief elements. Actual shadows and painted shadows play with one another. Questions are raised once again about representation and reality in a typically and provocatively Cubist fashion. Archipenko discussed the important role of shadows in his sculpto-paintings:

The advantage of sculpto-painting over the usual painting is that the lights and shadows of the relief are vitally real, unlike conventional painting in which there is only a painted illusion of the lights and shadows. Another advantage is that lights and shadows in sculpto-painting are changeable according to the changes of the source of the light, while in the usual painting they remain unchanged. There is also the advantage that under an adequate source of light the shadows in the sculpto-painting become integral parts of the composition. Sculpto-painting, due to its new technical expansion, intensifies the optical and esthetic effects of forms to a degree that makes usual painting and sculpture seem lifeless.[19]

Archipenko's Niçois statuettes and sculpto-paintings share a preoccupation with light and optical effects.[20] Given his residence in sun-drenched Nice, where the light is especially intense, this new interest is not surprising.

Archipenko's change from opaque to luminous paint is not only a response to the general milieu of the South but may also have been reinforced by a more specific source, the Russian artist Léopold Survage, who spent the war years in Nice. Archipenko first met Survage when they were students together in Moscow at the School of Painting, Sculpture, and Architecture. Survage, a painter passionately interested in color, saw paintings by Matisse and the Impressionists in Moscow in the collection of the well-known collector Sergey Schoukine and decided to move to Paris to study under Matisse. There he got in touch with Archipenko, and the two stayed close friends for the rest of their lives.[21]

In 1912–13 Survage began to create a film called *Les Rythmes colorés*. Although the film was not completed because of the outbreak of war, some two hundred drawings for it survive.[22] The non-representational images are composed of abstract geometric forms resembling rays of light. A highly innovative joining of the old

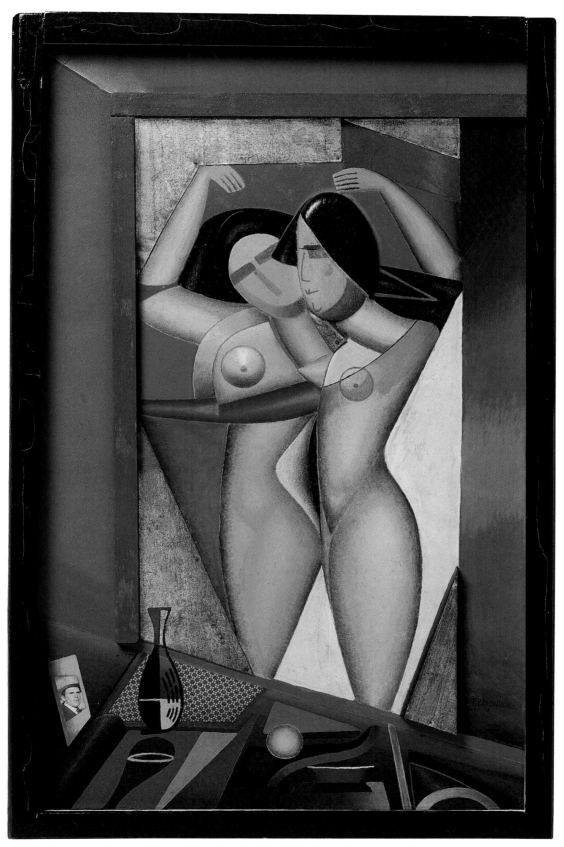

Fig. 23 Alexander Archipenko, *Before the Mirror (In the Boudoir)*, 1915, oil, graphite, photograph, and metal on panel, 18 x 12 in., Philadelphia Museum of Art. Gift of Christian Brinton, 1941.079.119.
Left: Fig. 22 Alexander Archipenko, *Woman Combing Her Hair,* 1916, bronze, ed. 10/12, 13 11/16 in. high, Private collection.

medium of painting and the new one of cinema, the images taken as a whole can be considered a Cubist film. It was especially advanced of Survage to consider color movies, for they had not yet been invented. The project received significant exposure—three of the designs were exhibited in Paris from March 1 to April 30, 1914, at the Salon des Indépendants[23]—and even captured the attention of Picasso.[24] It continued to be a topic of discussion until at least 1919 when Cendrars's article about Survage and his *Rythmes colorés* appeared in the July 17 issue of the periodical *La Rose rouge* in which he celebrated Survage's interest in the genesis of animated color. "It is as if we are witnessing the creation of the world," wrote Cendrars.[25]

Archipenko's enthusiastic interest in *Les Rythmes colorés* is reflected in his advice to Survage to show the project to Apollinaire.[26] The presentation, which was well received, resulted in Apollinaire's inviting Survage to contribute an essay on *Les Rythmes colorés* to the latter's review, *Les Soirées de Paris*. Survage's essay appeared in the July–August 1914 issue—just after the June 15 issue, which reproduced Archipenko's latest works. Apollinaire himself described the work in this poetic manner:

"The origins of this art can be traced back to fireworks, fountains, electric signs, and the fairy-tale luxury hotels we see in exhibitions, which have taught our eyes to derive pleasure from kaleidoscopic changes in shades.

We shall thus have a new art that will be independent both of static painting and cinematographic representation. It will be an art that people will quickly get used to and that will have infinite appeal for those who are sensitive to the movement of

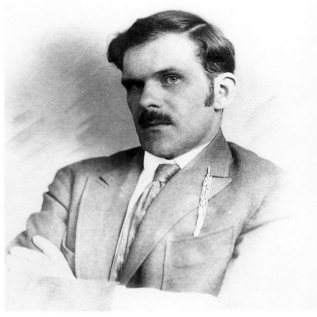

Fig. 25 Photograph of Alexander Archipenko, circa 1916, Alexander Archipenko Papers, roll NA23, frame 129, Archives of American Art, Smithsonian Institution, Washington, D.C.

colors, their interpenetration, their sudden or slow transformations, their juxtaposition or their separation etc."[27] In another text, Apollinaire poetically referred to Survage's *Rythmes Colorés* as "les concerts lumineux."[28]

Survage would have had three compelling reasons to move to Nice during the war: the sizable Russian community, the active movie industry, and the presence there of his friend Archipenko. In Nice, Survage's work took a marked turn toward both figuration and Cubism, while maintaining an underlying commitment to the representation of light: he produced a series of flattened cityscapes, as seen in *Nice*, circa 1916 (fig. 18). This work is dominated by contrasting complementaries: orange buildings nestled between the blue sky and water. The canvases seem like montages with close-ups and pans superimposed on one another. As Apollinaire wrote of Survage's Niçois work in 1917: "No one before Survage knew how to put in one canvas an entire city and the interiors of its homes. . . . His work serves as an iridescent bridge between the art that had been before the war and the magnificent soaring of the new painters."[29] While the subject of Survage's Niçois work is different from that of Archipenko, it too is a form of luminous Cubism. Together, Archipenko and Survage explored the possibilities of this new form of art.[30]

Fig. 24 Alexander Archipenko, *Seated Woman Combing Her Hair*, 1915, bronze, ed. 4/8, 21 1/8 in. high, Frances Archipenko Gray.

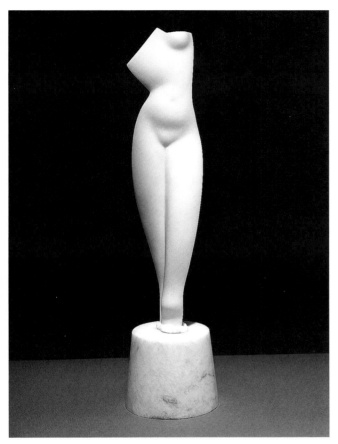

Fig. 26 Alexander Archipenko, *Flat Torso*, 1914, marble on alabaster base, 18 3/4 x 4 1/2 x 4 1/2 in., including artist's base: 3 3/4 x 4 1/2 x 4 1/2 in., Hirshhorn Museum and Sculpture Garden, Smithsonian Institution. Gift of Joseph H. Hirshhorn, 1966.

In addition to his sculpture and paintings, Archipenko developed a Cubist play early in 1917, called *La Vie humaine.* This multimedia project, to be done with the collaboration of the Belgian writer Franz Hellens and an unnamed Polish musician, was to include music, poetry, dance, and film.[31] Archipenko was responsible for the three-dimensional aspects. There were to be three stages, arranged on different levels; the middle one was to feature the main characters and actual objects, while the other two would have whimsical characters symbolizing the contradictory feelings of the protagonists. It was to be a terrestrial tragedy with accompanying heavenly and infernal scenes. Film would reinforce certain episodes: for example, a murder scene done with "brutal realism" would be projected on a screen. The opposition of good and evil were to create a real "human life," or drama. Interludes were to feature varied dances, singing, and music-hall bits, presumably to light-

en the mood. Hellens said that Archipenko was one of the first who was able to take from Cubist doctrines applications for actual possibilities. *La Vie humaine* was intended to be produced after the war in Russia at the Moscow Theater, but the project was never fully realized, evidently because of differences of opinion between Archipenko and Hellens. Nonetheless, the project underscores the collaborative creative spirit that permeated Nice during the war.

It is possible that Archipenko's interest in film was inspired by his friends Survage and Cendrars. Survage's continued interest in film is attested by the montage elements and presence of Chaplinesque figures, complete with bowler hats, in his Nice paintings (fig. 18). As for Cendrars, he and Archipenko were clearly in contact in Nice.[32] A cinematic influence can be seen in the dramatic poses struck by the figures in Archipenko's Niçois works. The "close-up" compositions of the sculpto-paintings and their bright, "glamorous" lighting further suggest a cinematic influence. It is fair to say that film, crucial to the origins of Cubism, continued to play a nurturing role in its development.[33]

Archipenko's Italian friend Amedeo Modigliani (fig. 30) was in the Nice area for thirteen months, from April 1918 to May 31, 1919, and the paintings he made there are now considered among his most important and desirable works. No longer stiff and angular, his figures became rhythmic and curvaceous. At the same time, his palette lightened and brightened, giving the works a certain buoyancy. This was a particularly productive time for Modigliani, and he painted a

Fig. 27 Alexander Archipenko, *Standing Figure*, 1916, faïence, approximately 12 in. high, Frances Archipenko Gray.

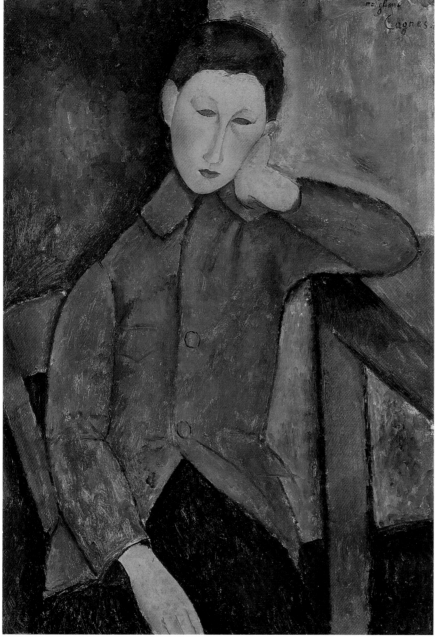

Fig. 28 Amedeo Modigliani, *The Boy* (or *Youth in a Blue Jacket*), 1918 or 1919, oil on canvas, 36 1/4 x 23 3/4 in., Indianapolis Museum of Art. Gift of Mrs. Julian Bobbs in memory of William Ray Adams, 46.22.

friends and acquaintances, including Hellens, the pianist Germaine Meyer (later Mrs. Léopold Survage),[35] the actor Gaston Modot,[36] Rachel Osterlind (wife of the painter Anders Osterlind), Morgan Russell, and the dealer Zborowski. Hellens remarked on how quickly Modigliani painted his portrait, but, although Hellens considered the painting inspired, he and his wife felt that it did not resemble him at all, so he sold it (for less than the twenty francs he paid for it).[37] The many portraits of Jeanne that Modigliani painted in and around Nice seem to be quite varied and also do not bear a striking resemblance to her (compared with the photographs of her that are reproduced in the Modigliani literature).[38] Not interested in realistic portrayals at this time, Modigliani used his sitters as sources of inspiration.

In a new development for him, Modigliani made many portraits of peasants and young people, such as the *The Boy* at the Indianapolis Museum of Art (fig. 28), signed "Modigliani Cagnes." Its light-hued palette is dominated by blue and green. The face of the young boy glows. The relaxed pose and sinuous outlines of the figure are characteristic of Modigliani's Riviera work. These new subjects may have resulted from several factors. Whereas Modigliani used professional models in Paris, there were none on the Riviera, and he had to use local people. These models resulted in works with enormous sentimental appeal that could easily be sold. Finally, given the birth of his daughter, Modigliani was doubtless thinking about children and young people.

Modigliani tried painting landscapes, including *Paysage à Cagnes* (fig. 29). These may owe something to Renoir, Modigliani's neighbor in Cagnes.[39] The landscapes are even more reminiscent, though, of the flattened landscapes or hillside scenes of Survage, who encouraged

steady stream of works, perhaps motivated to support his growing family. His girlfriend, Jeanne Hébuterne, was pregnant—a development that led to their move South, out of harm's way—and would give birth to a baby girl on November 29, 1918.

In Nice, and nearby Cagnes, Modigliani spent time with his old friends Archipenko, Cendrars, Foujita, Soutine, and Survage.[34] He made portraits of some

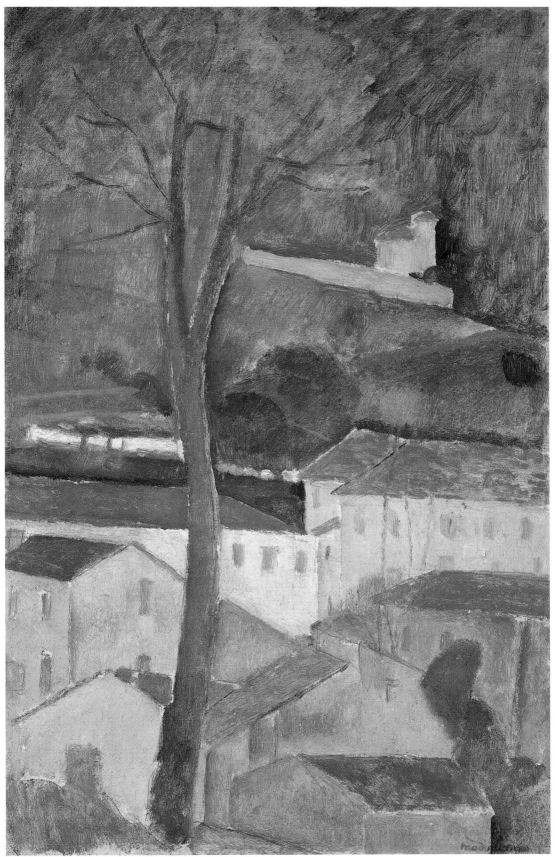

Fig. 29 Amedeo Modigliani, *Paysage à Cagnes (Landscape in Cagnes)*, 1919, oil on canvas, 18 1/8 x 11 1/2 in., Katherine M. Perls.

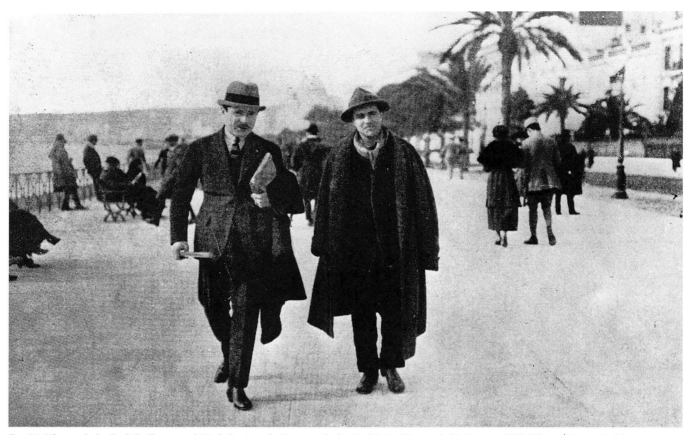

Fig. 30 The art dealer Paul Guillaume and Modigliani on the Promenade des Anglais in Nice, probably January 1919, Klüver/Martin Archive.

Modigliani to try the landscape genre.[40] Modigliani spent much time with Survage. Survage noted that Modigliani was too introspective and interested in the human spirit to continue painting landscapes. *Paysage à Cagnes* shows the rooftops of Cagnes with a building prominently featured in the upper right corner. Anecdotal evidence suggests that this was one of the houses in which Modigliani lived.[41]

Matisse (fig. 31), the third major artist to be discussed, moved to Nice in late 1917. His art changed significantly over the next few years in a direction that would characterize it for much of the interwar period.[42] The change has typically been called, or dismissed as, a "retreat" from an abstract, symbolic style to a more figurative Impressionist style, in which light and atmosphere reign supreme. Matisse's chief concern did indeed shift from color to light, no doubt prompted by the intense light of the Riviera. His visits to Renoir in 1917 and 1918 are also critical, as scholars and Matisse himself have observed.[43]

Impressionism may have nurtured the light, but it is not Impressionist light that we see in Matisse's Niçois paintings. Not airy and feathery with a suggestion of a specific time of day, it is rich, lush, and luminous. While the paintings may have become more figurative, they are also more visually intense, with different patterns and decorative motifs abounding. These qualities are seen to advantage in the Museum of Modern Art's painting *Interior with Violin Case* of 1918–19, painted at the Hôtel Méditerranée, where the patterned carpet and busy wallpaper are further enlivened by an outside light source. The intense visual experience produced in Matisse's Niçois works may be the result of several influences aside from the powerful light of the region and the artist's visits with Renoir.

One wonders, for example, the extent to which Matisse's concern with optical effects, specifically light, was inspired by the writer Jules Romains, with whom he was in "almost daily contact" in Nice in 1918–19.[44] Romains recounted how their conversations were not

limited to painting and literature but also touched on personal topics such as their respective beards. Matisse's friend Georges Besson commented on how the time Matisse and Romains spent together provided each of them an opportunity to refresh his artistic vision.[45] The closeness of Matisse and Romains is attested by the fact that Romains coauthored a book on Matisse in 1920, in which he acknowledges Matisse's individuality while pointing out that he is a classic artist who partakes of a rich and impressive tradition.[46] In addition, Romains owned several paintings by Matisse.[47]

We know that Romains was still very much interested in unanism, the theory that had made him a celebrity in 1908. Unanism is the idea that the bombardment of stimuli in the modern metropolis produces a group or collective consciousness, what some might call a Zeitgeist. Indeed, he was in the process of extending the concept from being about intense urban environments to village dynamics.[48] Matisse's Niçois works are unanimist in the sense that they are dominated by a strong mood of lush, quiet gentility. Light permeates every part of the composition and has an almost tangible presence. It serves to unify both inside and outside worlds.

The movie culture of Nice may also have been a factor in Matisse's changing art. Indeed, the art historian Dominique Fourcade has noted the cinematic quality of Matisse's Nice works:

> In another novelty from this period, Matisse's eye seems to proceed like a camera, engaging in a long traveling from canvas to canvas, going from a close-up to an increasingly distant view (or the inverse), showing a part of the scene and then the whole scene, varying the angles of the points of view. Since each different sequence consists of a single canvas, one would have to reunite all of them in order to complete the cinematography of his pictorial universe.[49]

Fourcade's casual observation deserves serious consideration given the strong presence of cinematic culture in Nice then.

Aside from the visits with Romains and Renoir, other artistic contacts may have played a part. Matisse was aware of Archipenko's work there, for example, writing a letter to Henri Laurens from Nice on May 9, 1918, saying, "Are you still making sculptures with coloring? I've

Fig. 31 Henri Matisse, courtesy of the Bancroft Library, University of California, Berkeley.

seen here Archipenko who is still making colored sculptures."[50] Matisse would also have seen Survage, his former student. Like Archipenko and Survage, Matisse was moved to make visually rich and intense images, works in which there is an interplay between interior and exterior worlds. For all of these artists, and Modigliani as well, the depiction of light was a primary concern.

The war period in Nice was a pivotal time for many artists and the artistic history of the region. The art of Archipenko, Modigliani, and Matisse in particular took important and dramatic turns during their time there. In addition, this artists' community-in-exile helped establish Nice, and the Riviera generally, as an artist's mecca. The interwar years saw the area blossom as it never had before.

THE MEDITERRANEAN MUSE

ARTISTS ON THE RIVIERA BETWEEN THE WARS

KENNETH E. SILVER

Fig. 32 Raoul Dufy, *Nice, La Baie des Anges (Nice, the Bay of Angels)*, 1932, oil on canvas, 14 7/8 x 18 in., The Metropolitan Museum of Art. Bequest of Miss Adelaïde Milton de Groot (1876–1967), 1967, 67.187.67.

ARTISTS AND TOURISTS

If at the turn of the twentieth century the Riviera was still an out-of-the-way retreat for aristocratic foreigners and adventurous Frenchmen, by the 1920s it had become a well-known resort. Its place in popular mythology dates from this period after World War I, when France's hundred-or-so-mile southeastern "azure coast" became familiar (by way of words and images, if not actual travel) to an international audience.[1] Artists played an important role in the creation of the Côte d'Azur's mythic status from at least as early as Monet's sojourns in Antibes in the 1880s.[2] But it was during the interwar years that the Riviera gained a real artistic profile, when large numbers of Parisian artists, and many artists from abroad, went there to work and play. Matisse, Picasso, Gris, Dufy, Van Dongen, Masson, Kisling, Man Ray, Picabia, Lartigue, Cartier-Bresson, Beckmann, Klee, and Kandinsky, to name only some of the best known, all made art on the Côte d'Azur in the 1920s and 1930s.[3]

With a few exceptions, these artist-visitors shared the experience of most other tourists on the coast: they went for a more-or-less brief period of time, usually ranging from a week to several months; they enjoyed the pleasures of the Riviera while inhabiting hotel rooms or rented houses; and then they left. And the artist and tourist shared something else as well: a predisposition for the visual. Unlike the family member who travels to visit relatives, or the businessman or -woman who travels for commerce, or the university professor who travels to lecture, the tourist travels, first and foremost, to look. The term *sight-seeing* succinctly expresses, in apparent redundancy, this closed-circuit, touristic apprehension of new places. Of course, the modern artists who went to the coast took the process one step further than even the most indefatigable tourist equipped with a camera—they created art out of what they saw. Yet, the work these artists made on the Riviera remains, whatever its intentions, marked by the tourist experience. How could it be otherwise, in a place that had become, by the 1920s, the most stylish and celebrated seaside resort in the world?

In *Nice, La Baie des Anges (Nice, the Bay of Angels)*, of 1932, by Raoul Dufy (fig. 32), ten tourists take in the

Fig. 33 Raoul Dufy, *Fontaine à Hyères (Fountain at Hyères)*, circa 1927–1928, oil on canvas, 18 x 14 7/8 in., Colby College Museum of Art, Waterville, Maine. Gift of Miss Adeline F. and Miss Caroline R. Wing, XX-P-013.

sights of Nice and its Bay of Angels. Judging by their hats and heavy coats this must be winter, the fashionable season on the Côte d'Azur until the mid-twenties (when the summer season gradually became more stylish).[4] Dufy's visitors are standing on the promontory known in Provençal as the *Rauba Capeu*—the turning of the celebrated shoreline road, the Promenade des Anglais—which affords a view that includes, at the right, the Quai des Etats-Unis, where Henri Matisse lived part of each year, and of the beach where he kept the boat he rowed as a member of Nice's Club Nautique (a pair of rowboats pulled up on the beach is clearly visible in Dufy's painting).

In an almost ceremonial way, Dufy frames his group with two prominent palm trees, nonindigenous plants that flourish all along the Côte d'Azur, but which were only brought there in the nineteenth century (the rough-skinned specimen at the left is probably the *palmier des*

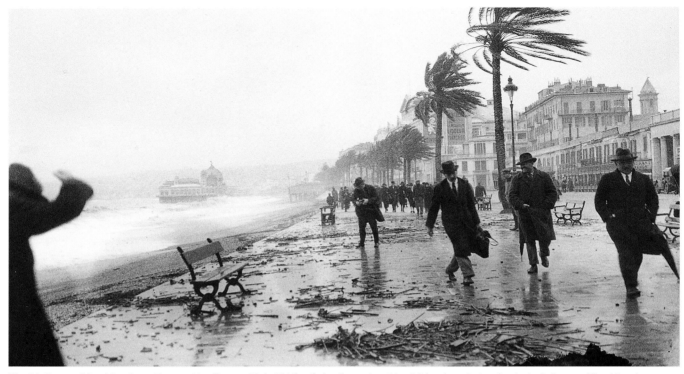

Fig. 34 Jacques-Henri Lartigue, *Tempête à Nice (Storm at Nice)*, 1925, gelatin silver print, 12 x 16 in., Association des Amis de Jacques-Henri Lartigue, Paris, 1925-I.

canaries and the smooth-skinned one at right probably the *sabal*). The bright green of their fronds and the tonally allied azure of the sea and sky are contrasted to a bit of pinkish road, at left, and the red tile roofs of the city in the distance, a coloristic tour de force for which the entire image seems no more than a delightful excuse. Green appears as well in the walls of the curious-looking, vaguely Moorish structure, with its gold cupola, that extends into the sea in the middle distance—the Jetée-Promenade, an establishment with which Dufy's visitors were undoubtedly familiar. The late-nineteenth-century iron-and-glass Jetée-Promenade, complete with cafés, restaurants, game rooms, and a theater, was the center of Nice's touristic nightlife, until it was destroyed during World War II.[5]

Nice, La Baie des Anges is a classic example of Dufy's post-Fauve style. His is essentially a draftsman's art adapted to painting: quick touches of black calligraphy, with modeling kept to a minimum, played off against large, flat areas of brilliant hue. Like Dufy's work in general, it is a mix of the faux naïve and the ultrasophisticated and as such is the perfect expression of the Riviera tourist experience, itself a kind of willed regres-

sion practiced by urbanites. True, Dufy is not Gauguin, and Nice is not Tahiti; neither the artist nor the depicted tourists are likely to attempt losing their "civilized" identity among the "natives." But, although the Riviera was a place where one could gamble and dance, and show off one's wardrobe, it was also a place where one might become uninhibited enough to take a bath, in saltwater or sweet, in one of Nice's many bathing establishments, even if one did not go as far as taking a dip in the sea. More important, Dufy's depicted tourists went to the Côte d'Azur for the same reasons that most of us travel—for visual refreshment, for a new perspective, for a change of scene from daily life. This is the point of the stroll taken by these ten gazers: to gain a certain distance from the city, to apprehend Nice as a site.

It is altogether appropriate that Dufy's strong colors and unwavering attention to the surface of things construe Nice as a decorative backdrop, or a painted *carte postale*. For not only had Dufy worked in both easel painting and the decorative arts (including textile design for fashion and home furnishing), but as a frequent visitor to the coast since 1903 he was well versed in the

Fig. 35 Jacques-Henri Lartigue, *La Méditerranée (The Mediterranean)*, September 1927, gelatin silver print, 12 x 16 in., Association des Amis de Jacques-Henri Lartigue, Paris, 1927-186.

local beauty spots. He had chronicled these, by means of lovely etchings, for Gustave Coquiot's 1925 ode to Provençal life, *La Terre frottée d'ail* (The Land Rubbed with Garlic). There Dufy created images of the most distinctive panoramas, local monuments, and town squares of the ports and inland villages of the Midi, including Marseille, Toulon, Saint-Tropez, Antibes, Nice, Vence, and Hyères, often referred to in travel literature as Hyères-les-Palmiers—where he chose to represent the large, three-tiered fountain, with elaborate sculptural decoration, in the center of town. This is also the subject of Colby College's painting of 1927–28, by Dufy (fig. 33), in which twin palms again flank the motif and a hill rises in the background.

Another artistic point of view akin to the tourist's, but with a much greater interest in the activities of those who were native to the region, is that of the American painter William Glackens. He began his artistic career in New York as a member of the Ash Can School, a group known for its representations of street life in New York; he developed toward a late Impressionist style borrowed from French art, and with it an interest in French life. Regular visitors to France,

Glackens and his family rented houses in three spots on the Côte d'Azur over a period of seven years. Two winters of the late 1920s were spent at the Villa les Pivoines, above Vence. (Vence is the hill town between Nice and Cannes, where fellow American painter Marsden Hartley [fig. 57] worked in 1925–26 and where he painted *Purple Mountains, Vence* [fig. 36]), with its bipartite palette of green and pinkish farmland, in the foreground, and pink and purple hills, rising to the snow-covered Maritime Alps, behind. Vence is also where Matisse and Chagall would live decades later.) The summer of 1930 was spent at the Villa les Cytharis, at La Ciotat (where the painters Braque and Friesz worked in 1907), and the summers of 1931 and 1932 at the Villa des Orangers, at Le Suquet, in Cannes (where, among others, Van Dongen, Picabia, Picasso, and Lartigue worked at various times).[6]

Apart from the great influence exerted on his style by the "local" master, Renoir—who lived for many years, until his death in 1919, at the Villa les Collettes, in nearby Cagnes—the lives of the local *azuréens* cast their spell on Glackens. At La Ciotat, near Marseille, he painted several versions of local men playing *boules*, a

41

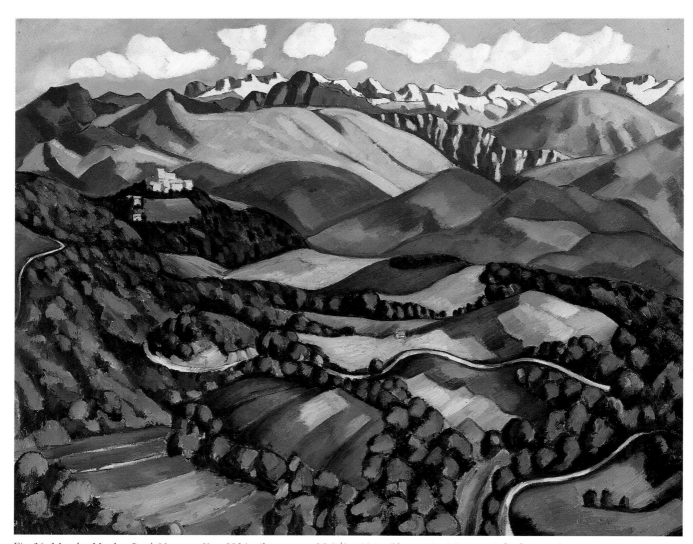

Fig. 36 Marsden Hartley, *Purple Mountains, Vence*, 1924, oil on canvas, 25 1/2 x 32 in., Phoenix Art Museum. Gift of Mr. and Mrs. Orme Lewis, 77.147.

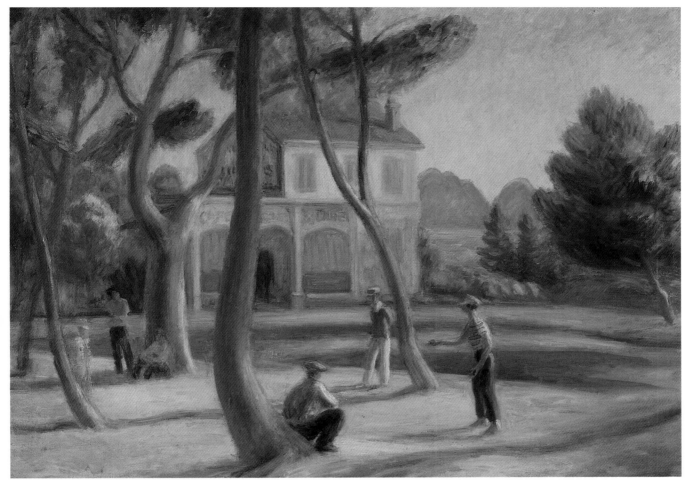

Fig. 37 William J. Glackens, *Bowlers, La Ciotat*, 1930, oil on canvas, 25 x 30 in., Museum of Art, Fort Lauderdale, Florida. Ira Glackens Bequest, 92.31.

traditional Mediterranean game (the Cercle des Boulo-manes, the oldest *boules* club in existence, was founded in Marseille in 1828). With a palette and feathery paint handling borrowed from Renoir, Glackens creates a picture of timeless pastoral entertainment (fig. 37). Four men, all sporting the kind of nautical headgear that is typical of the region, watch a fifth man pitch the small metal ball; he leans just slightly forward from the waist, with arm extended, in the approved manner. The game transpires in a grove of five pine trees, as afternoon light illuminates the scene, causing the pines to cast long shadows. A sixth tree, at the extreme right edge of the painting, echoes the leftward tilt of the bowler (several trees here lean left, blown that way by the winds from the sea). A café with enclosed terrace makes up the middle ground, and a view of distant hills across the bay is visible in the background.

Glackens's picture is a synthesis of a way of life, one that attracted so many of the artists, and tourists, who went to the Riviera for something other than nightclubs and posh hotels. In *Bowlers, La Ciotat*, the same pastimes prevail, in the same light, and on the same shores, as those of our most distant, Mediterranean ancestors. This is "local color" in its most picturesque, Arcadian form. Although tourism was gradually altering these old ways during the interwar years that the Glackens family was sojourning in the South—as the locals were becoming aware of the profitable, "performative" aspects of their rituals[7]—it was a way of life that, in some respects, has tenaciously prevailed to the present day. One can still see games of *boules* being played in many of the town squares along the Riviera, a favorite activity of local retirees, as well as of their children and grandchildren. Likewise, fêtes are still a regular part of life in the

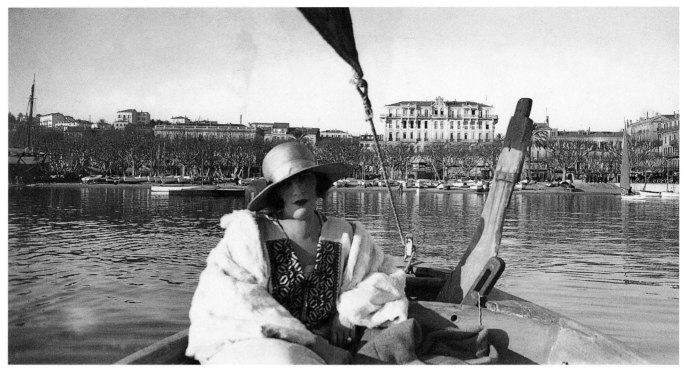

Fig. 38 Jacques-Henri Lartigue, *Bibi, Cannes*, January 1923, gelatin silver print, 12 x 16 in., Association des Amis de Jacques-Henri Lartigue, Paris, 1923-046.

South of France—celebrating Bastille Day (fig. 40), for instance, or the patron saint of the town, the subject of Glackens's lively *Fête du Suquet (The Suquet Festival)*, of 1932 (fig. 41). It depicts the festivities in the "old city" of Cannes, Le Suquet, which rises up the steep slope of Mont Chevalier, just to the west of the port.

CAMERA LUCIDA

The recording of the local scene, particularly in its more active aspects, is more efficiently rendered by photography, the form of touristic documentation that has come to dominate all others. The Côte d'Azur's rise to celebrity in the years between the wars coincides precisely with the camera's rise to preeminence, as well as with the coming-of-age of the Riviera's greatest photographer, Jacques-Henri Lartigue. Lartigue was twelve years old, equipped with his first camera, when he visited the Riviera with his family for the first time: Juan-les-Pins, Antibes, Cannes, Nice, and Menton were all on that first itinerary. From that point on, for most of this nearly depleted century, Lartigue regularly absented himself from Paris for extended sojourns on the coast, producing pictures of "high life" there that are as beautiful,

clever, buoyant, and as attentive to the specificities of the place, as any ever made (figs. 34, 35, 49). To be sure, the lives of the local inhabitants were of limited interest to Lartigue; his photographs are mostly glimpses of the stylish pastimes of his fashionable, café-society friends (figs. 38, 39, 44, 45, 50). Pictures of the car races in Antibes, of the Ziegfeld Follies girls in Monte Carlo, of the Mardi Gras in Nice, and later, of movie stars at the Cannes Film Festival, alternate with the daily activities of his intimates—getting dressed for dinner in his room at the Carlton, stopping for lunch in Saint-Tropez, drinking an aperitif at sunset at Cap d'Antibes, exercising on the beach in Cannes (fig. 48). Despite this activity, Lartigue considered himself primarily a painter, and while he regularly exhibited his canvases (many of the Côte d'Azur), his photographs were neither exhibited nor published until 1963, at which point they were hailed as great, modernist efforts in the medium. Lartigue's photographs were made, not for a public, but for himself, as highly personal traces of a private life, the visual corollaries of the written diaries he kept his whole life long. The Riviera we see in Lartigue's pictures is an enchanted place of fortunate and immensely attractive

people in elegantly choreographed motion and perpetually alluring *décontraction*. Yet, they are not the cold and artificial pictures of the rich at play that one might expect, but warm evocations of a time and place that touch us with the grandeur, and pathos, of their fleeting glimpses of that most intangible of things—the happy life.[8]

Henri Cartier-Bresson also photographed on the Riviera at several points. The portrait series he made of Matisse at his rented villa in Vence, and of Bonnard at his house in Le Cannet, both in 1944, are among the most celebrated portraits that exist of twentieth-century artists. But the pictures for which Cartier-Bresson first became known are mostly of anonymous men- and women-in-the-street, photographs in which a split second of time reveals to us the essence—the pattern—of something that had previously passed unnoticed. "For Cartier-Bresson showed us the unreality of reality," wrote Beaumont Newhall, "the rhythm of children playing in ruins, a child lost to the world as trance-like he catches a ball, a bicyclist streaking by iron grill work."[9] The last of these images, that of the cyclist, was taken in 1932 (fig. 53), the year Cartier-Bresson acquired his first Leica (the remarkable, small 35-millimeter German camera that revolutionized the medium after its introduction in 1924). It was made in Hyères, the site of Dufy's painting (and the town where the American novelist Edith Wharton had a house, next door to which the modern-art patrons Charles and Marie-Laure de Noailles had Robert Mallet-Stevens build them an extraordinary modern villa [figs. 85-91]). The modernity of Cartier-Bresson's image is evident in both its capturing of the cyclist's speed, one of the key sensations of modern life, and its vantage point: the exhilarating view, in Hyères's Old City, down a flight of stone steps, its complicated patterns intensified by the patterns of the grillwork of the metal handrail and the confining line of the cobblestone street's far curb. The piquancy of the photograph resides in precisely this contrast between old and new, between the unchanging stone- and metalwork of Old

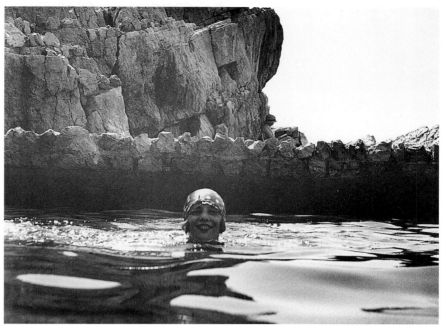

Fig. 39 Jacques-Henri Lartigue, *Bibi, Cap d'Antibes,* May 1920, gelatin silver print, 12 x 16 in., Association des Amis de Jacques-Henri Lartigue, Paris, 1920-056.

Hyères and the momentary apparition of youthful speed and exuberance.

Indeed, Cartier-Bresson's elevated vantage point is one that characterizes the visual regime of both the tourist and the modernist. Standing on balconies and terraces over the sea, or on parapets overlooking distant hills, or at the edges of cliffs or hills atop the shoreline—as Dufy's sightseers are—the tourist positions him- or herself at an elevated remove from the life of the local inhabitants. It was the experiencing of awe-inspiring views, which lifted one above the "particular" to the "general"—be they of the Roman Campagna or the Alpine passes—that was one of the goals of the romantic travelers on the Grand Tour in the late eighteenth and early nineteenth centuries.[10] By the time of our own century, the elevated viewpoint could just as easily be a sign of modernity itself, especially for photographers: the perspective available to those atop the Eiffel Tower, or in a skyscraper, or aboard an airplane. *Marseille, Port View [Old Harbour],* of 1929, by Hungarian photographer László Moholy-Nagy (fig. 54), is an image that captures both the touristic and the modernist in a single glimpse of the Mediterranean. A collection of small fishing boats in Marseille's picturesque Old Port (as distinct from the ocean liners and huge cargo ships that

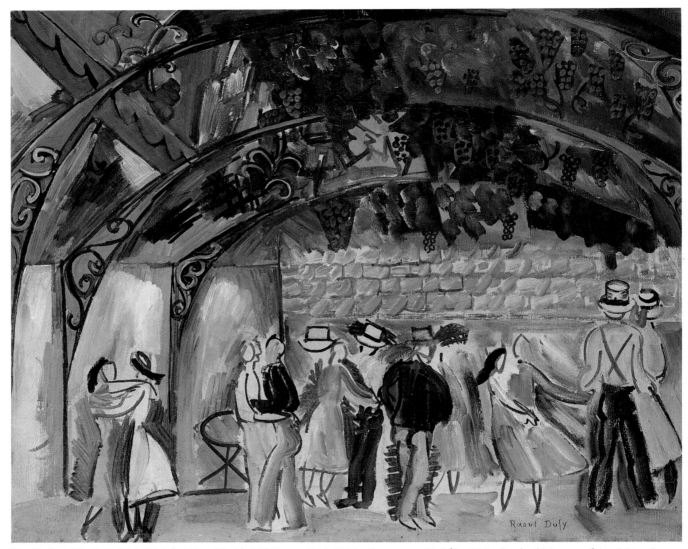

Fig. 40 Raoul Dufy, *Le Bal du 14 Juillet à Vence (The July 14th Dance in Vence)*, 1920, oil on canvas, 21 1/2 x 26 in., Portland Museum of Art, Maine. Lent by Mildred Otten, The Albert Otten Collection, 10.1993.71.

were docked in its nearby modern harbor) constitute an exercise in pure, modernist pattern making. Forming a diagonal grid that is only slightly tipped away from the picture plane, our viewpoint seems to defy gravity, and perhaps to mystify us, unless we know—as many viewers may have at the time—that Moholy-Nagy was standing atop the Pont Transbordeur. Referred to as the "Eiffel Tower of the South," the engineer Ferdinand Arnodin's 1905 iron-and-steel structure—a kind of drawbridge over the Vieux Port—was composed of twin pylons nearly eighty-five meters high, and a crosspiece roadbed suspended from a vast network of support cables.

Connecting the north and south sides of the city, the Pont Transbordeur loomed over Marseille's skyline until World War II. In addition to Moholy-Nagy, Germaine Krull, Herbert Bayer, André Papillon, and Florence Henri all made photographs of, or from, the Transbordeur during its forty-year life as the great symbol of modern engineering on France's southern coast.[11]

On a more down-to-earth level, one concerned less with the imperatives of modernist abstraction and more with the notion of photography's special purchase on the "real," that is, its documentary potential, is a picture by the Transylvanian-born Brassaï, of a man shielding

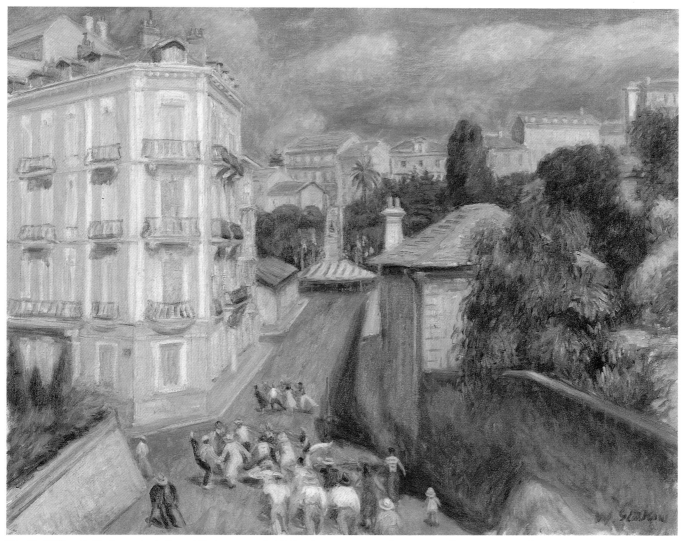

Fig. 41 William J. Glackens, *Fête du Suquet (The Suquet Festival)*, 1932, oil on canvas, 25 3/4 x 32 in., Whitney Museum of American Art, New York. Purchase, 33.13.

Fig. 42 Brassaï (Gyula Halász), *Côte d'Azur/L'Ombrelle, Menton (Côte d'Azur/the Umbrella, Menton)*, 1934, gelatin silver print, 11 9/32 x 8 29/32 in., The J. Paul Getty Museum, Los Angeles, 84.XM.1024.7.

Fig. 43 Lisette Model, *Promenade des Anglais, Nice*, circa 1934, gelatin silver print, 11 3/8 x 9 1/8 in., The J. Paul Getty Museum, Los Angeles, 84.XM.153.52.

himself from the sun beneath his umbrella (fig. 42). He is seated on a bench on the aptly named Promenade du Soleil, at the water's edge in Menton, the town farthest east on the French Riviera, at the border of Italy. Brassaï's anonymous man, who has gone to a bit of trouble to deny the very sun-and-sea that is the Côte d'Azur's raison d'être, is obviously meant to make us laugh. He is a kind of anti-sun-worshiper, an anomaly, who turns a cold shoulder to the *belle vue* to look back at the town, something he could just as well have done with less exertion in Paris, or Lyon, or Bordeaux.

More ambiguous in tone, and probably all the more powerful for that, are the most famous "documents" of anonymous Côte d'Azur sitters, the portraits made by Lisette Model on Nice's Promenade des Anglais about 1934 (fig. 43). For the most part middle-aged or older, Model's typically well-heeled café denizens sit on one variety or other of lounge chair, usually with the same basket-weave paving tiles at their feet (this may be the café of the Hôtel Westminster, a popular daytime spot

in the 1930s). Although there are exceptions, most of her sitters do not smile, and many look back at the photographer with suspicious expressions. They may have been asking themselves who this young woman was who was photographing them, and wondering where their images might end up. As well they might have, inasmuch as Model's pictures accompanied an article the next year, "Côte d'Azur," by Lise Curel, published in the magazine *Regards*. There, presumably with the photographer's consent, they became evidence for a Marxist indictment of the middle-class Riviera tourist. "The Promenade des Anglais is a zoo," wrote Curel, "to which have come to loll in white armchairs the most hideous specimens of the human animal." And she continued:

These comfortably-off people who spend their time getting dressed, making themselves beautiful, doing their nails, and putting on makeup, never manage to hide their decadence, the incommensurable wasteland of middle-class thinking. The middle-class is ugly. Sprawling on chaises longues under the fairest of

Fig. 44 Jacques-Henri Lartigue, *Abel Gance, Beauvallon*, 1927, gelatin silver print, 16 x 12 in., Association des Amis de Jacques-Henri Lartigue, Paris, 1927-038.

Fig. 45 Jacques-Henri Lartigue, *Mary Belewsky, Cap d'Antibes*, May 1941, gelatin silver print, 16 x 12 in., Association des Amis de Jacques-Henri Lartigue, Paris, 1941-004.

skies, before the finest of seas, these people are revealed for what they are: irredeemably old, disgusted, disgusting.[12]

Curel's interpretation of Model's pictures—whatever the photographer's own intentions—represents the flip side of Lartigue's Riviera, the pleasures of the leisure class seen through another lens, one that renders them decadent and abhorrent. It is an exceptional if not unique attitude toward the Côte d'Azur, but one that is not altogether surprising given the highly politicized nature of so much cultural commentary in the prewar era of the 1930s.

ARTISTS IN RESIDENCE
Usually, as we have seen, France's southeastern coast was constructed as a little piece of paradise on earth, an idyllic spot for *la vie sportive*, or alternatively, the *vita contemplativa*, a place where one could lose oneself in thought. Surely, this is what the American painter Milton Avery intended to convey in his *March on the Balcony*, painted in Nice in 1952 (fig. 46). Here, the artist's daughter is shown lost in the midst of a reverie, beside an open window to the sea, with a sailboat and the distant shore of the bay framed by the shutters— what the French exotically call *persiennes*—and the grill-work of the balustrade. Needless to say, the clear antecedent in French art for this American's picture—in its emphasis on two-dimensionality and color, as well as its subject matter of female sitter beside the open window—is Henri Matisse, who more-or-less patented this sort of Riviera image in the interwar years.

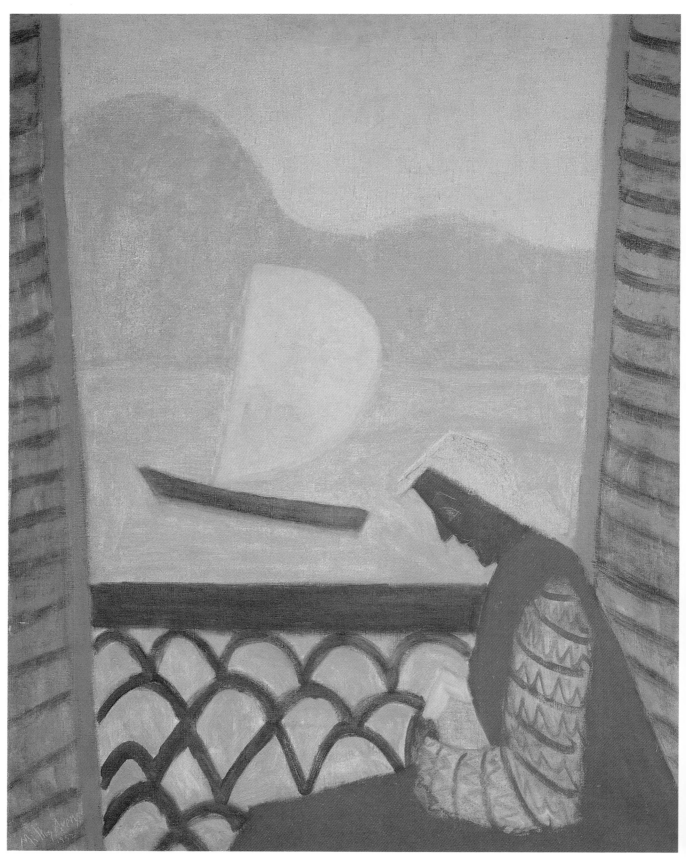

Fig. 46 Milton Avery, *March on the Balcony*, 1952, oil on canvas, 44 x 34 1/8 in., The Phillips Collection, Washington, D.C.

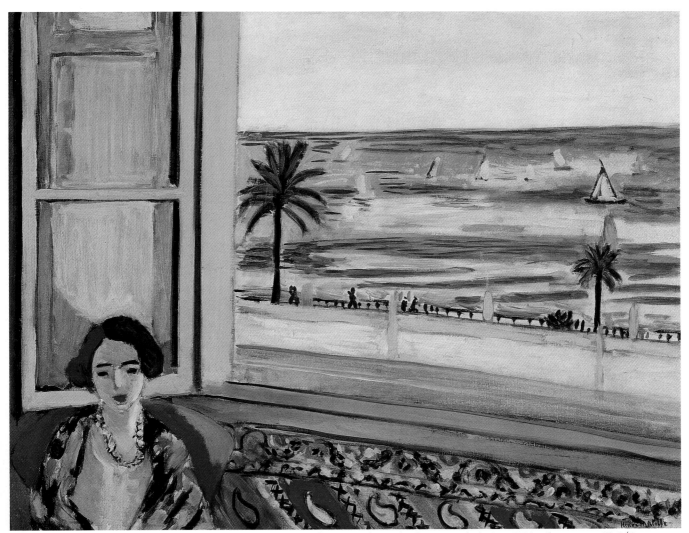

Fig. 47 Henri Matisse, *Femme assise, le dos tourné vers la fenêtre ouverte (Seated Woman, Back Turned to the Open Window)*, circa 1922, oil on canvas, 28 3/4 x 36 1/2 in., The Montreal Museum of Fine Arts. Purchase, John W. Tempest Fund, 1949.1015.

After Matisse's arrival there in 1917, in the midst of World War I, Nice became a second home to the artist and eventually his fulltime residence. It is in Cimiez, the neighborhood high up in the hills overlooking Nice, where the artist lived during his last years and where he is buried, that the Musée Matisse is located. Probably even more than Picasso—who took up residence in so many different places on the Côte d'Azur—the name Matisse is the one most closely associated with modern art on the Riviera, and more particularly with Nice's Promenade des Anglais (Matisse lived on or near the promenade from 1917 to 1937). Yet the pictures he made there during the 1920s, exquisite evocations of an artful, contemplative life, represent a long period of aesthetic retrenchment for the painter. Unlike the work Matisse had been producing for the fifteen years prior to his arrival in Nice, the art he made during his first decade in the largest city on the Côte d'Azur is normative rather than revolutionary.[13] Whereas Matisse's painting, with its flattened forms and abbreviated shapes, had been continually verging, from about 1906 to 1917, on the abstract, after 1917—and for the entire next decade in Nice—there is an unequivocal return to conventional picture making, as critics of the period were quick to note.[14]

In Matisse's Nice pictures of the 1920s, three-dimensional, illusionistic space is reasserted as a pictorial given; chiaroscuro and shadow, at least in summary indication, return; and color is far more naturalistic. Not that Matisse entirely forgot, or repudiated, what he had learned as a high modernist, for these works are, in fact, filled with resonances of his earlier, radical pictorial

strategies. In *Femme assise, le dos tourné vers la fenêtre ouverte (Seated Woman, Back Turned to the Open Window)*, of about 1922 (fig. 47), and *Woman in the Window, Nice*, of 1926 (fig. 51), the large window is pushed up so close to the picture plane, and in the latter case tilted at so extreme an angle, that an assertion of the canvas's two-dimensionality—a basic tenet of the modernist pictorial mandate—is apparent. (The horizontal striped fabric beneath the window in *Vase de Fleurs devant la Fenêtre [Vase of Flowers before a Window]* accomplishes a similar assertion of the picture's flatness). In *La Séance de Trois Heures (The Three O'Clock Sitting)*, 1924 (fig. 52), the traditional chiaroscuro of the draped model as well as the shadows cast by the legs of the easel and chair and beneath the armoire and on the far right wall are countered by a minimum of modeling of the figure of the woman painting, of the floor, the armoire and its mirrored front, and the North African fabric in the right background. And while none of the colors jolt us with the purely poetic license that Matisse took in earlier paintings—like the *Red Studio*, 1911, or the *Blue Window*, 1913, or the *Piano Lesson*, 1916 (all, The Museum of Modern Art, New York)—the colors of the Nice period paintings are pushed to an extreme of naturalism, without ever exceeding the believable, for the sake of the decorative ensemble. *Woman in the Window, Nice*, for instance, the picture of a drizzly day, is a study in mauves, pinks, grays, blacks, and ochers, with just a brilliant touch of burnt siena to warm up the image at the lower left. *Femme assise*, depicting a bright day on the Promenade des Anglais, is a medley of cool azure and green in the upper half, juxtaposed to a percussive strip

Above: Fig. 48 Jacques-Henri Lartigue, *Cannes*, April 1929, gelatin silver print, 10 1/2 in. diameter, Association des Amis de Jacques-Henri Lartigue, Paris, 1929-041.

Fig. 49 Jacques-Henri Lartigue, *Tournage du film, "Les Aventures du Roi Pausole," Cap d'Antibes (Filming of "The Adventures of King Pausole," Cap d'Antibes),* August 1932, gelatin silver print, 16 x 12 in., Association des Amis de Jacques-Henri Lartigue, Paris, 1932-024.

Fig. 50 Jacques-Henri Lartigue, *Renée, Juan-les-Pins,* May 1930, gelatin silver print, 16 x 12 in., Association des Amis de Jacques-Henri Lartigue, Paris, 1930-014.

of intense red, yellow, brown, black, and blue below. *Three O'Clock Sitting,* with its myriad patterns and gridlike rendering of interior space that make us think of the reassuring seventeenth-century Dutch interiors of De Hooch and Vermeer, is all warmth, with its reds, oranges, and yellows relieved only by the coolness of the blue dress of the painter, the green of the hanging textile, and, of course, the blue of the sea outside the window.

Matisse's Nice paintings of the 1920s represent, then, a reinvestment in traditional artistic practice, enlivened by the artist's earlier, modernist strategies. They are ruminative works in a way that nothing he had made hitherto had been, imbued with a pervasive mood of quietude. His models sit and stare into space, or read a book, or even, now and then, work on their own paint-

ings, and there is nothing exceptional in any of this—it is what artist's models have been pictured doing for centuries. But that, of course, is the point of these pictures, which are intended to remind us of a long tradition of representation, not to shock us with formal or iconographic innovation.

Matisse's Côte d'Azur is, for the most part, an interior place, a world of rooms—in hotels and apartment houses—all of which give onto the Promenade des Anglais and the sea. Matisse's is a tourist's view par excellence, a tourist whose greatest pleasures are derived from his lodgings and his vistas, from the distance he keeps from the place he visits, and from his private way of being in a highly public place. We are unmistakably in Nice: we rarely lose sight of the Mediterranean, or a palm tree, or an occasional stroller, but they are always

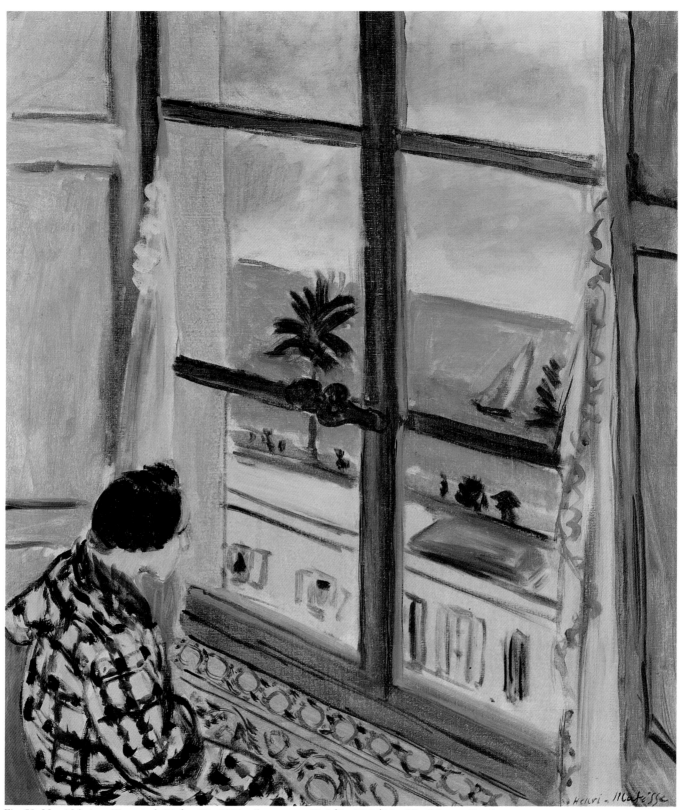

Fig. 51 Henri Matisse, *Woman in the Window, Nice,* 1926, oil on canvas, 28 1/2 x 23 1/2 in., The Saltzman Family.

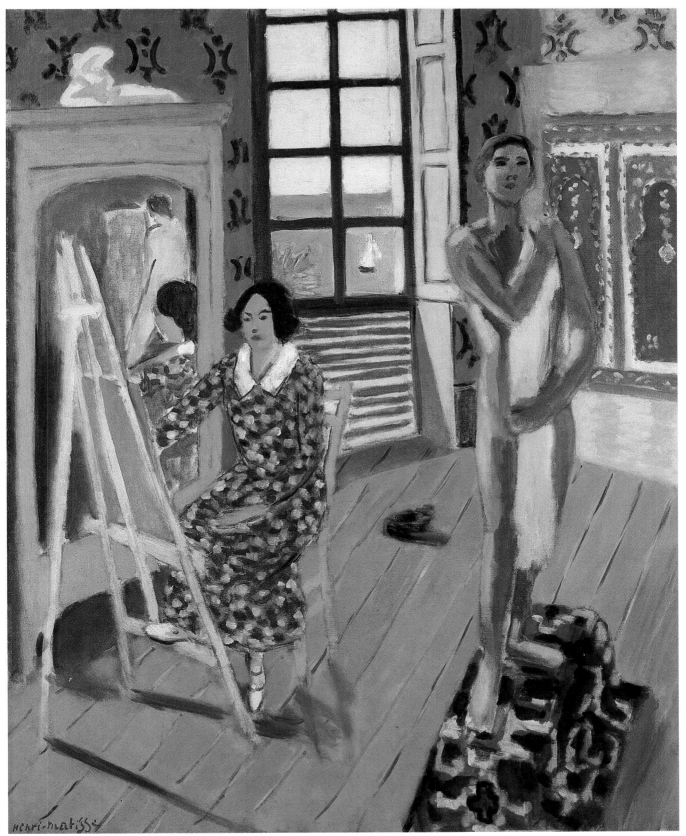

Fig. 52 Henri Matisse, *La Séance de Trois Heures* (*The Three O'Clock Sitting*), 1924, oil on canvas, 36 1/4 x 28 3/4 in., Portland Museum of Art, Maine. Lent anonymously, L36.

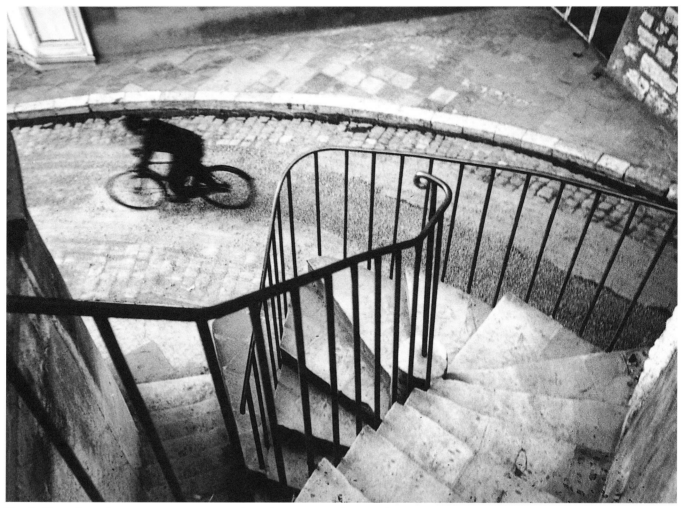

Fig. 53 Henri Cartier-Bresson, *Hyères, France,* 1932, gelatin silver print, 13 1/4 x 19 3/4 in., George Eastman House, 77:759:2.

most emphatically "out there," not "in here" with us. One senses throughout these works—unlike the Fauve-era pictures he made outdoors, on his terrace and at the beach in Saint-Tropez, about 1905—that, apart from the brilliant light, what most attracted the artist to the Côte d'Azur was its extreme distance from Paris. On the coast, Matisse could see people when and how often he wanted to. His family, his friends and acquaintances, and his dealers, although they sometimes visited him in the South, were often back in Paris, and this seems to have suited Matisse well. He could imagine himself on a continual working vacation—one in which he could take stock of what he had accomplished and think about where he wanted to go, without the pressures of the capital. Here, alongside the sea, Matisse was an artist

"in retreat," one who divested himself of Parisian life and aesthetics, found a comfortable middle ground of pictorial endeavor, and mined it for all it was worth. In the last decade of his life, still in Nice, Matisse would return to his earlier commitment to abstraction and to pure pictorial effusion, but that was far in the future. For the time being—what is really Matisse's "middle period"—the art he made on the Riviera would be distinguished by its sense of equilibrium and refinement.

A NATURAL PARADISE

The German Expressionist painter Max Beckmann made something quite different of the Côte d'Azur, at least to judge by the raw, intense picture he painted at Beaulieu in 1947 (fig. 55). Beckmann had been a regu-

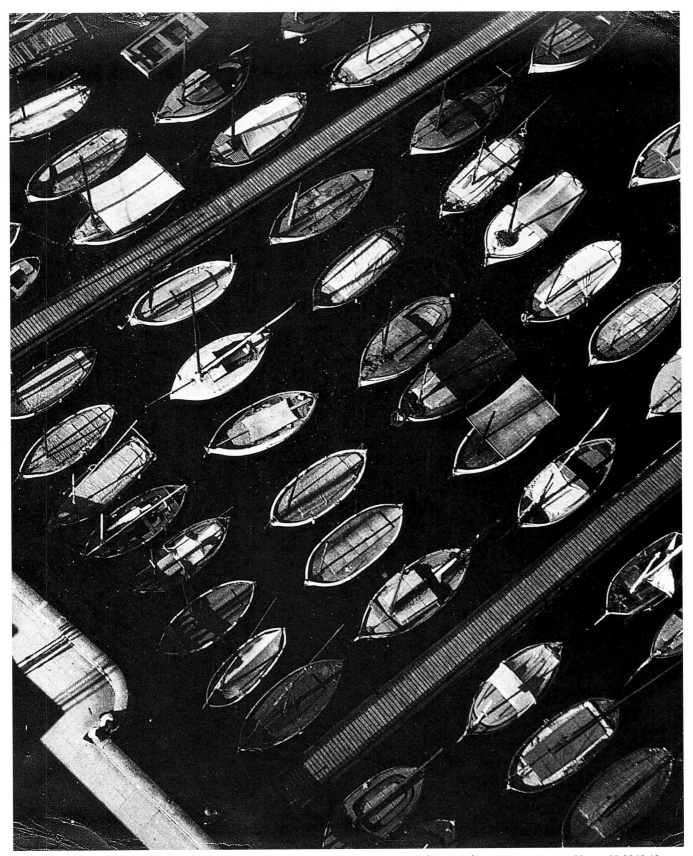

Fig. 54 László Moholy-Nagy, *Marseille, Port View [Old Harbour]*, 1929, gelatin silver print, 19 1/4 x 14 3/4 in., George Eastman House, 81.2163.43.

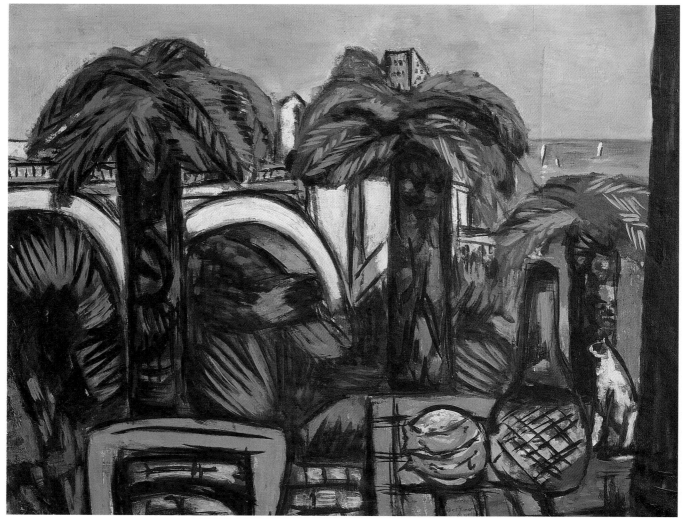

Fig. 55 Max Beckmann, *Beaulieu*, 1947, oil on canvas, 31 5/8 x 39 3/8 in., Krannert Art Museum and Kinkead Pavilion, University of Illinois, Champaign.

lar, short-term visitor to the Riviera. He had painted all along the coast—in Marseille, Toulon, Cannes, Monte Carlo, Nice, and, just to Nice's east, at Beaulieu—for many years. If Matisse's Riviera is an Apollonian dream of calm and order, Beckmann's is Dionysian, a vitalistic vision of exuberant flora shooting up at the water's edge. With his characteristic black outlines and rough paint application, which is typical of so much of the Expressionist art from which his own derives, what might otherwise be a benign still life with landscape is transformed into a picture of primordial energy. Beckmann's palm trees, with their thick trunks and effulgent fronds, look almost prehistoric; in comparison to Dufy's ceremonial, architectonic palms, Beckmann's

appear wild and untamed, not the "orientalizing" decorative vegetation of nineteenth-century planners but an aboriginal form of nature's will-to-life. It is as if Beckmann has retrieved, for this frankly peculiar tree (which gives almost no shade), some of the strangeness and vitality that is neutralized in so many other artists' depictions of the Côte d'Azur.

And if Beckmann's Riviera is pre-Edenic, Pierre Bonnard's is Eden itself. Yale's *Paysage du Midi (Landscape in the Midi)* of 1926 (fig. 56) was painted at Le Bosquet, the house that Bonnard purchased in 1926 at Le Cannet, the hill town above Cannes (a street of which Man Ray had photographed, with a splendid, enormous palm tree in the center, three years earlier) (fig. 58).

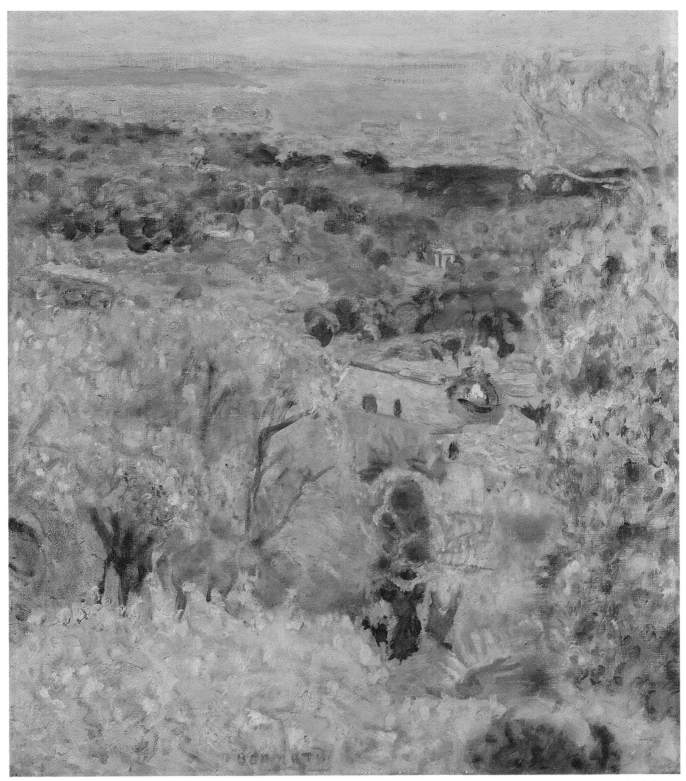

Fig. 56 Pierre Bonnard, *Paysage du Midi (Landscape in the Midi)*, 1926, oil on canvas, 20 1/4 x 16 1/2 in., Yale University Art Gallery. Bequest of Edith Malvina K. Wetmore, 1966.79.1.

Fig. 57 Marsden Hartley on the beach at Cannes, 1925, Marsden Hartley Memorial Collection, Bates College Museum of Art, Lewiston, Maine.

Bonnard was already quite familiar with the Riviera by the time he bought his house. Previous to several seasons of rentals in Le Cannet, he had lived and worked for short periods in Grasse and Saint-Tropez as well. In becoming a property owner Bonnard was following the precedent of Renoir at Cagnes, both of them exceptional among artists who worked on the coast, most of whom rented their rooms or houses. Perhaps the model for Bonnard and Renoir was Claude Monet at Giverny. Like him, they created small, ideal worlds of cultivated nature that became the source of a seemingly inexhaustible catalogue of pictorial subjects.

Bonnard painted pictures not only in his garden but throughout his house as well: whether in his studio, the living/dining room, or the bathroom—where he made so many memorable images of his wife, Marthe, stretched out in the tub—Bonnard was able to transform his personal environment at Le Bosquet into an intimate dreamspace for generations of spectators. Of all those made on the Riviera between the wars, Bonnard's Le Cannet paintings (and drawings, too, of

which he made many) are the least touristic. They are the pictures of a property owner or, rather, of a man well settled on his apportioned fragment of nature's bounty. (There was still a goatherd in the neighborhood when Bonnard first moved to Le Cannet.) Although Bonnard was not completely indifferent to super-chic Cannes and its seaside thoroughfare, the Croisette (where he painted a number of wonderful works), most of his time and energy were expended representing his house and garden high above the aristocratic resort. Sometimes we can glimpse the roofs of the city in the distance, as well as the high wall of crests created by the nearby Esterel mountain range, or, as in *Paysage du Midi,* the Mediterranean Sea as a distant apparition of blue or silver. Yet they are secondary elements to his primary concern, Le Bosquet, with its tangle of thickets, its palms, aloes, and fruit trees. *Paysage du Midi* is a kind of visual tone poem of exquisitely blanched greens, ochers, blues, and violets, with a complicated perspective that first falls away down the hill and then slowly rises out across the landscape, culminating in the suggestion of the city and bay at the top of the painting. Neither a site of folkloric interest nor a place of the modern traveler's encampment, Bonnard's Riviera is the artistic realization of a fin-de-siècle ambition: to cross the threshold—by means of complete absorption in the motif—from nature's empirical facts to the dream's splendid and gorgeous excess.

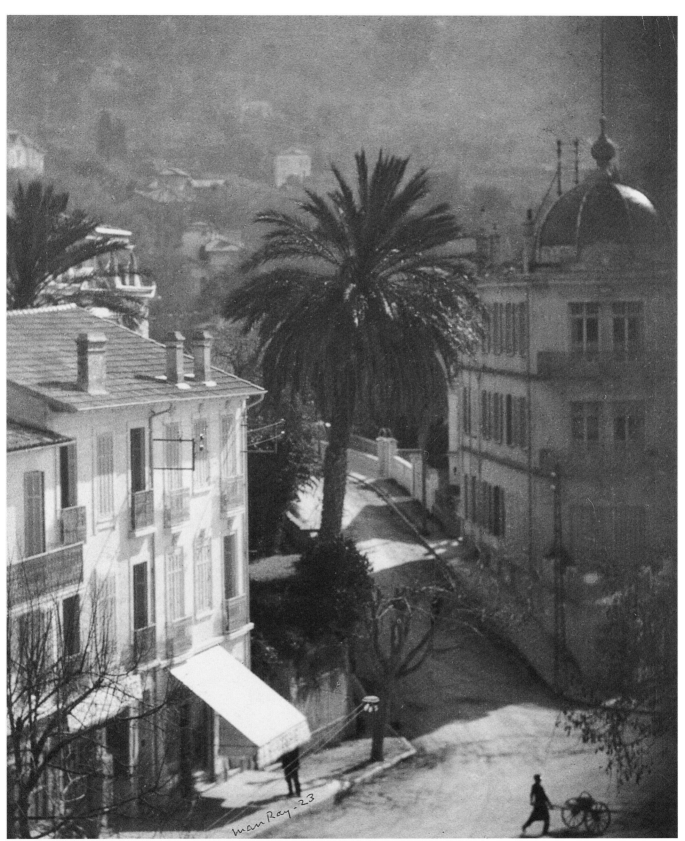

Fig. 58 Man Ray *Le Cannet, Landscape of the Midi (Paysage du Midi)*, 1923, gelatin silver print, 10 5/8 x 8 7/16 in., The J. Paul Getty Museum, Los Angeles, 84.XM.1000.44.

Fig. 59 Olga, Paulo, and Pablo Picasso with François de Gouy d'Arcy, Juan-les-Pins, 1925 or 1926.

Fig. 60 François de Gouy d'Arcy and Picasso, Juan-les-Pins, 1925 or 1926.

Fig. 61 Olga, Jean Hugo, and Picasso, Juan-les-Pins, 1925 or 1926.

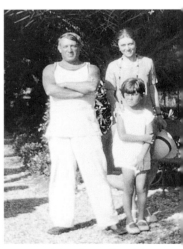

Fig. 63 Pablo, Olga, and Paulo Picasso, Juan-les-Pins, 1925 or 1926.

Figs. 59–66, 70–77 courtesy of Kimberley Greeley Brown, Portland, Maine.

Fig. 62 Picasso, Juan-les-Pins, 1925 or 1926.

Château and Villa Life on the Riviera During the Jazz Age

A Pictorial Essay

Kenneth Wayne

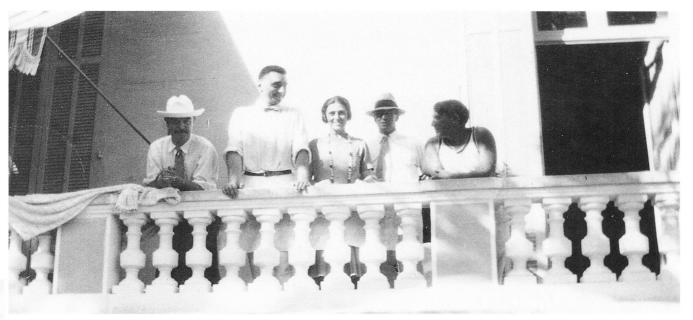

Fig. 64 François de Gouy d'Arcy, Jean Hugo, Olga, Russell Greeley, and Picasso, Juan-les-Pins, 1925 or 1926.

Château and villa life flourished on the Riviera in the mid-to late 1920s. With the postwar period of reconstruction officially over in France, it was acceptable to play again. Unscarred by the war, the Riviera held particular appeal. Of special importance in drawing aristocrats and the well-heeled away from Paris to the Riviera was the fast all–first class Train Bleu, or Blue Train, which made its first run in December 1922.[1] This train inspired the Diaghilev ballet of the same name, which featured a story by Jean Cocteau, music by Darius Milhaud, and costumes by Coco Chanel. Several new artistic salons arose on the Riviera, providing artists, writers, and socialites with places to congregate.

The area was especially popular among Americans. It was a well-established American tradition in the late nineteenth and early twentieth century for serious artists to travel to France for enrichment. In the 1920s, when America was gripped by Prohibition and the dollar was especially strong against the French franc, France lured and kept Americans as never before.[2] Wealthy Americans found an especially welcome community on the Riviera.

Château de Clavary, Auribeau (near Grasse)

In 1925 Russell Greeley (1878–1956), a portrait painter born near Boston and educated at Harvard University (class of 1901),[3] purchased and then renovated the Château de Clavary, a building originally constructed about 1820.[4] Located in Auribeau, a small town near Grasse approximately five miles inland, the château offers spectacular views of the cliffs of the Esterel. In her autobiography, published in 1932, the English painter Nina Hamnett evokes the first impression

Fig. 65 Postcard of man-made lake at Château de Clavary, circa 1928.

that the château made on her visit there about six years earlier: "The yellow flowers in the sunlight were so bright and dazzling that one had to blink one's eyes for a few seconds before one could see. . . . The whole lawn was covered in the biggest and sweetest smelling violets that I have ever seen. . . . I felt that at last I had arrived in Paradise."[5] The estate also contains an artificial lake (fig. 65), where, according to the painter Jean Hugo, Greeley swam every day.[6]

Greeley lived at the château with his friend, the half-English half-French artist and bon vivant François de Gouy d'Arcy. Hamnett said that de Gouy d'Arcy was "the most intelligent person I have ever met. He seemed to have read everything that had ever existed."[7] She also recalled Stravinsky's visit to the château: "We always had a tin of *caviare pressé* which I had to spread thinly on toast. Stravinsky seized a spoon and dug spoonfuls out of the tin and then played on our harmonium the fair tune of Petrouchka."[8] She noted that Poulenc composed all morning long during his stay there.[9]

The guest book and photo albums from the Château de Clavary (maintained by Greeley's heirs in Portland, Maine), reinforced by published accounts, allow us to contruct a list of the château's amazing array of visitors from about 1925 to 1938: artists (Constantin Brancusi, Kees van Dongen, Nina Hamnett, Jean and Valentine Hugo, Marie Laurencin, Fernand Léger, Man Ray and his friend Kiki, Francis Picabia and Germaine Everling-Picabia, Picasso, Dunoyer de Segonzac, Tristan and

Greta Tzara, Christopher Wood[10]), composers (Georges Auric, Arthur Honegger, Darius Milhaud, Francis Poulenc, Igor Stravinsky, Germaine Tailleferre), patrons of the arts and society figures (Edith and Etienne de Beaumont, Eugenia Huici Errazuriz, Jean Godebski, Walter and Mary Osgood Hoving, Marie Blanche and Jean de Polignac), performers (the actor Pierre Bertin and his pianist wife Marcelle Meyer, the singer/actress Marthe Chenal, and the dancer Isadora Duncan), and writers (Jean Cocteau, René Crevel, Robert Desnos, Max Jacob, Maurice Maeterlinck, Jacques Rigaut, Paul Valéry).[11] Art dealer Léonce Rosenberg and impresario Serge Diaghilev also visited.

An inscription under Max Jacob's image in the photo album notes that he was the "1er hôte," or first guest, giving an indication of just how close he was to his hosts. In a letter to Poulenc in March 1926, Max Jacob wrote, "If you see de Gouy and Greeley, tell them that they are as dear to me as my blood, my skin, my pen and Poetry itself."[12]

Of particular interest at the Château de Clavary is a black-and-white mosaic by Picasso (fig. 67).[13] It depicts a series of interlocking profiles composed of undulating lines that give it a strong Surrealist flavor. It is located in the foyer, or what Jean Hugo called *le fumoir*, or smoking room. Picasso is reputed to have stopped by the château shortly before his death in 1973 to see the mosaic one last time.[14]

Fig. 66 Pages from Château de Clavary guest book, 1926–38. Man Ray's signature is visible on left; Picasso's on right.

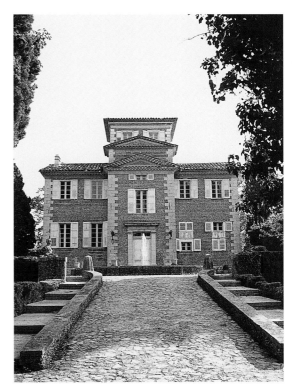

g. 67 Mosaic at Château de Clavary, circa 1930, by Picasso. Photograph taken ly 1997.

Fig. 68 Driveway and front entrance of Château de Clavary. Photograph taken July 1997.

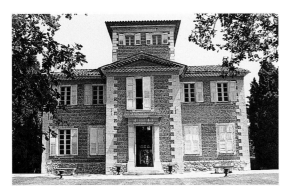

Fig. 69 Patio area behind Château de Clavary. Photograph taken July 1997.

Fig. 70 Man Ray photograph of
Russell Greeley, Paris, 1922.

Fig. 71 François de Gouy d'Arcy, Marcelle Meyer, Olga and Pablo Picasso, and Russell Greele[y]
on front right lawn of Château de Clavary, 1925.

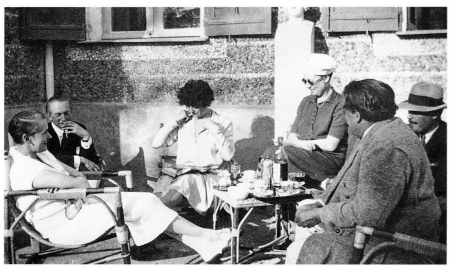

Fig. 72 Germaine Everling-Picabia, Russell Greeley, Marthe Chenal, Nina Hamnett, Francis Picabia,
and François de Gouy d'Arcy, in back patio area of Château de Clavary, 1925 or 1926.

Fig. 73 Dressed-up statue, in back patio area of
Château de Clavary, 1925 or 1926.

Fig. 74 Dressed-up statue, in back patio area of
Château de Clavary, 1925 or 1926.

Fig. 75 Marie Laurencin, Château de Clavary, 1925 or 1926.

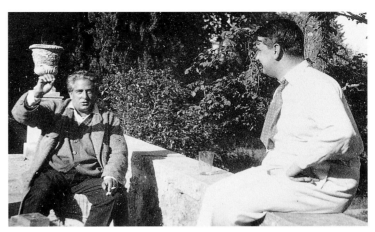

Fig. 76 Francis Picabia and Georges Auric, Château de Clavary, circa 1926.

Fig. 77 Max Jacob, Château de Clavary, 1925.

Fig. 78 Marie Laurencin, Château de Clavary, 1925 or 1926.

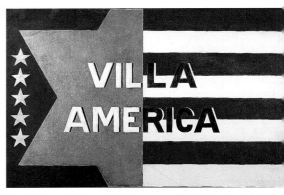

Fig. 79 Gerald Murphy, *Villa America*, 1925, oil and gold leaf on canvas, 14 1/2 x 21 1/2 in., Private collection.

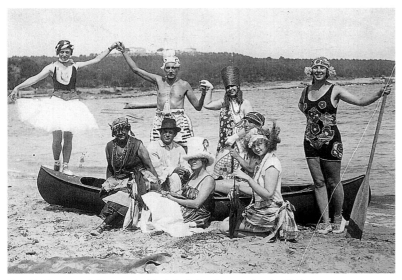

Fig. 80 Picnic with Picasso (in black hat), La Garoupe beach, 1923.

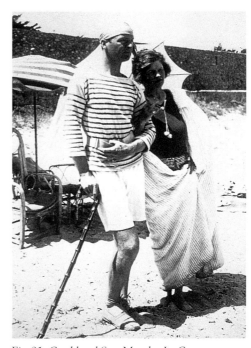

Fig. 81 Gerald and Sara Murphy, La Garoupe beach, 1923.

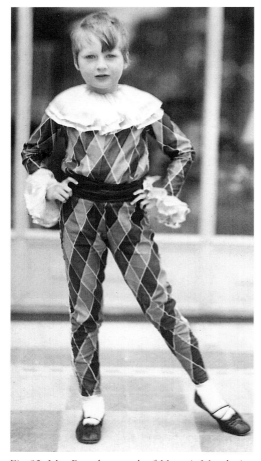

Fig. 82 Man Ray photograph of Honoria Murphy in harlequin costume at Villa America, circa 1926.

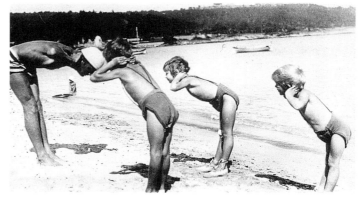

Fig. 83 Gerald Murphy and his children doing stretching exercises on La Garoupe beach.

Figs. 79-84 courtesy of Honoria Murphy Donnelly.

VILLA AMERICA, CAP D'ANTIBES

Gerald and Sara Murphy bought and renovated a villa in Antibes that they called Villa America.[15] It was ready for occupancy late in July 1925 and featured a large and fragrant garden. Gerald Murphy was an American businessman-turned-artist whose family owned the Mark Cross pen company. He was an exceptional artist who produced but a handful of canvases.[16] His flattened, colorful style shows the influence of Cubism, particularly Léger, and billboard advertising.

The Murphys created a charmed and exciting life at the Villa America that has since become legendary. They ate well, listened to jazz from Gerald's extensive record collection, and entertained the leading literary and artistic figures of their day: Robert Benchley, John Dos Passos, F. Scott Fitzgerald, Ernest Hemingway, Archibald MacLeish, and Dorothy Parker as well as such artists as Picasso and Léger. MacLeish remarked about the Murphys that "person after person—English, French, American, everybody—met them and came away saying that these people really are masters in the art of living."[17] Igor Stravinsky confirmed that view, saying, "The Murphys were among the first Americans I ever met and they gave me the most agreeable impression of the United States."[18] F. Scott Fitzgerald used Gerald and Sara Murphy as inspiration for the characters Dick and Nicole Diver in his book *Tender Is the Night* and dedicated the book to them.

Fig. 84 Villa America, circa 1926.

VILLA NOAILLES, HYÈRES

In 1923 Charles and Marie-Laure Noailles commissioned Robert Mallet-Stevens to build a villa in Hyères on land that they had recently received as a wedding present.[19] At the top of a hill, the land contains medieval ruins that the architect used to provide a dynamic counterpoint to his very modern structure. The Noailles were able to spend the first of their annual stays in November 1925. Visitors and guests included Georges Auric, Luis Buñuel, the Giacometti brothers, Henri Laurens, Darius Milhaud, and Francis Poulenc.[20] The playful antics that took place there have been recorded by Man Ray in his 1929 film *Les Mystères du Château du Dé*, which was commissioned by the Noailles. One sees a particular emphasis on sport in the film, as figures dive in the villa's pool and play in its large gymnasium; sports were an aristocratic pastime, for the wealthy were the only ones who had the time and resources to indulge in such leisure activities.

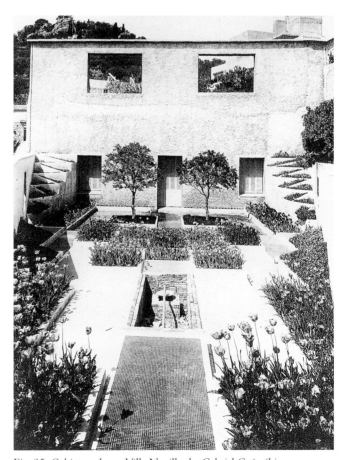

Fig. 85 Cubist garden at Villa Noailles by Gabriel Guévrékian.

Fig. 86 Villa Noailles, circa 1928.

Fig. 87 The pool and terrace, metallic chairs by Robert ⟩
Stevens from *Art et Décoration*, July 1928.

Fig. 88 Still from Man Ray's 1929 film *Les Mystères du Château du Dé*, courtesy of
the Museum of Modern Art/Film Stills Archive.

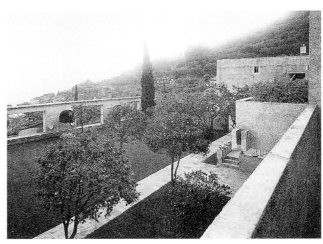

Fig. 89 Front garden of the Villa Noailles, circa 1928.

Fig. 90 Detail of still from Man
Ray's 1929 film *Les Mystères du Château
du Dé*, courtesy of the Academy of
Motion Picture Arts and Sciences.

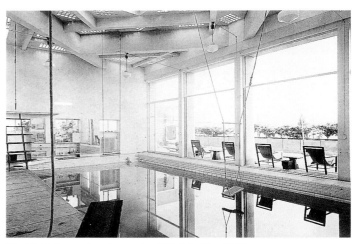

Fig. 91 Indoor swimming pool at Villa Noailles, 1928.

Francis Picabia's Château de Mai, Mougins (near Grasse)

In 1925 Francis Picabia built his Château de Mai in Mougins and packed it full of his cherished collectibles.[21] In her memoirs, his wife, Germaine Everling-Picabia, recounted life at the château, noting the very impressive list of visitors there: Pablo and Olga Picasso, Jeanne and Fernand Léger, Yvonne George, Jacques Doucet, Robert Desnos and Paul Eluard, Gerald Murphy, Rolf de Maré, Gertrude Stein, Marcel Duchamp, Roland and Hania Dorgelès, Jean Cocteau, Jean Desbordes, René Clair and his wife, Marthe Chenal, Brancusi, Roland Toutain, and many others.[22]

Madame Everling-Picabia recounts the story of how Brancusi brought a group of American women to the château one day. Upon seeing the swimming pool there, they decided to take a swim, undeterred by the fact that they did not have bathing suits with them. They simply swam naked. Evidently the story reached the local village and forever marked the way villagers viewed the Château de Mai and life there.[23]

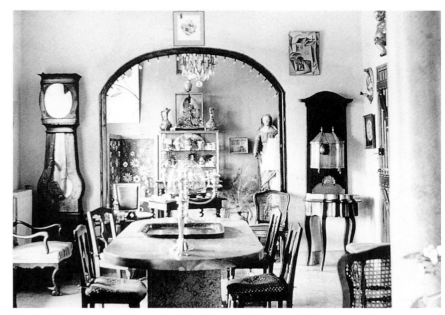

Fig. 93 Dining room of Francis Picabia's Château de Mai, circa 1930, courtesy of Olga Picabia, Paris.

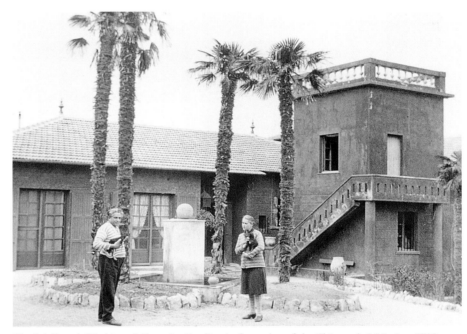

Fig. 94 Francis Picabia and Germaine Everling in the garden of the Château de Mai, circa 1930, courtesy of Olga Picabia, Paris.

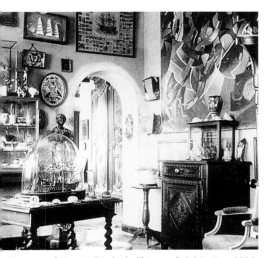

Interior of Francis Picabia's Château de Mai, circa 1930, ⸱e painting *Petite Udnie* on wall at right, courtesy of Olga ⸱, Paris.

THAT MAGICAL LIGHT: IMPRESSIONISTS AND
POST-IMPRESSIONISTS ON THE RIVIERA

1. John Pemble, *The Mediterranean Passion: Victorians and Edwardians in the South* (Oxford: Clarendon Press; New York; Oxford University Press, 1987), 17–18, 84–96.

2. J. Henry Bennet, *Mentone and the Riviera as a Winter Climate* (London: John Churchill, 1861), I, 13.

3. Charles Lenthéric, *La Provence maritime ancienne et moderne* (1879; Paris: E. Plon, 1880), 23.

4. Georges Rivière, *Renoir et ses amis* (Paris: H. Floury, 1921), 250.

5. For further discussion of the relationship between landscape painter and tourist, see John House, "Framing the Landscape," in *Impressions of France: Monet, Renoir, Pissarro, and Their Rivals*, exh. cat. (Boston: Museum of Fine Arts, Boston, 1995–96); British edition, *Landscapes of France: Impressionism and Its Rivals* (London: Hayward Gallery, South Bank Centre, 1995), esp. 14–19, 28–29. I use the personal pronoun *his* because the painters who explored the region were almost without exception male. Berthe Morisot, the only Impressionist woman artist to paint in the South, confined herself to Nice and its suburbanized surroundings. For the landscapist Félix Ziem's eloquent description of *his* first railway trip from Paris to Marseille about 1863, see Félix Ziem, *Journal (1854–1898)* (Arles and Martigues: Actes Sud, 1994), 208–9.

6. Alexander M. Brown, *Wintering at Menton on the Riviera: A Compagnon de Voyage with Hints to Invalids* (London: J. and A. Churchill, 1872), 2–3.

7. Charles Garnier, *Artistic Features of Bordighera*, in Frederic Fitzroy Hamilton, *Bordighera and the Western Riviera* (London: E. Stanford, 1883), 336–62.

8. See John House, *Monet: Nature into Art* (New Haven and London: Yale University Press, 1986), 23–25.

9. Maurice Denis, "Paul Cézanne," *L'Occident* (September 1907), reprinted in *Du symbolisme au classicisme: Théories* (Paris: Hermann, 1964), 165, and in P. M. Doran, ed., *Conversations avec Cézanne* (Paris: Collection Macula, 1978), 173.

10. Eugène Fromentin, *Une Année dans le Sahel* (1858; Paris: Plon-Hourrit, 1907), 230–32.

11. Théophile Gautier, "Salon de 1857," *L'Artiste* (5 July 1857): 247.

12. For an important discussion of these conventions, see Richard Shiff, *Cézanne and the End of Impressionism* (Chicago and London: University of Chicago Press, 1984), 199ff.

13. See Jean-Roger Soubiran, *Le Paysage provençal et l'école de Marseille avant l'impressionnisme, 1845–1874*, exh. cat. (Paris: Réunion des musées nationaux; Toulon: Musée de Toulon, 1992).

14. See Jean-Roger Soubiran, "Les Naturalismes et la Provence, 1880–1900," in *Peintres de la couleur en Provence, 1875–1920*, exh. cat. (Paris: Réunion des musées nationaux, 1995), esp. 33–36, 41–43.

15. Letter from Cézanne to Pissarro, 2 July 1876, in *Paul Cézanne, Correspondance*, ed. John Rewald (Paris: B. Grasset, 1978), 152.

16. Rau Foundation, Zurich; see *Cézanne*, exh. cat. (Philadelphia: Philadelphia Museum of Art, 1996), 164–66.

17. Letter from Guillemet to Emile Zola, 6 October 1876, in Soubiran, *Le Paysage provençal et l'école de Marseille*, 155; for Guillemet's art at this date, see *Impressions of France*, 126–27.

18. Jean Renoir, *Renoir, mon père* (Paris: Librairie Hachette, 1962), 228.

19. Letters from Monet to Duret, 2 February 1884, and to Durand-Ruel, 11 March 1884, in Daniel Wildenstein, *Monet: biographie et catalogue raisonné*, 5 vols. (Lausanne and Paris: La Bibliothèque des Arts, 1979), 2: nos. 403, 442.

20. Open letter to Trublot [Paul Alexis], published in *Le Cri du peuple*, 29 March 1889, quoted in *Signac*, exh. cat. (Paris: Musée du Louvre, 1963–64), 23.

21. Letter from Signac to Van Gogh, April 1889, in *The Complete Letters of Vincent Van Gogh* (London: Thames and Hudson, 1958), 3:153.

22. The effect of the small colored "points" in early Neo-Impressionist paintings cannot be discussed in terms of optical mixture or fusion, because from a normal viewing distance the separate colored elements remain visible; on this, see Robert L. Herbert, *Neo-Impressionism*, exh. cat. (New York: Solomon R. Guggenheim Museum, 1968), 17–21, and, in the context of Signac's paintings of the South, see esp. Erich Franz, "Paul Signac et la libération de la couleur de Matisse à Mondrian," in *Signac et la libération de la couleur*, exh. cat. (Grenoble: Musée de Grenoble, 1997), 19–23.

23. John Rewald, ed., "Extraits du Journal inédit de Paul Signac," *Gazette des Beaux-Arts* 36 (July–September 1949): 106, entry for 29 September 1894.

24. Rewald, "Journal inédit de Paul Signac," 126, entry for 1 September 1895.

25. Denis, "Henri-Edmond Cross," preface to 1907 exh. cat., reprinted in *Théories*, 153–54.

26. Denis, as in no. 9.

27. Emile Bernard, "Paul Cézanne," *L'Occident* (July 1904), reprinted in Doran, ed., *Conversations avec Cézanne*, 36–37.

28. Letter from Derain to Vlaminck, in André Derain, *Lettres à Vlaminck* (Paris: Flammarion, 1994), 161–62.

29. E. Tériade, "Matisse Speaks," *Art News Annual* (1952), reprinted in Jack D. Flam, ed., *Matisse on Art* (London: Phaidon, 1973), 132.

30. Letter from Signac to Charles Angrand, 14 January 1906, in *Henri Matisse, 1904–1917*, exh. cat. (Paris: Centre Georges Pompidou, 1993), 72.

31. On the Fauves' paintings of the South, see Judi Freeman et al., *The Fauve Landscape*, exh. cat. (Los Angeles: Los Angeles County Museum of Art; New York: Abbeville, 1990).

32. Marc Elder, *A Giverny chez Claude Monet* (Paris: Bernheim-Jeune, 1924), 71.

33. Garnier, *Artistic Features of Bordighera*, 354.

34. Letter from Ziem to Rousseau, 1860, facsimile published in *Souvenirs de voyages*, exh. cat. (Paris: Musée du Louvre, 1992), 136.

35. See Richard Thomson, *Monet to Matisse: Landscape Painting in France, 1874–1914*, exh. cat. (Edinburgh: National Gallery of Scotland, 1994), 78.

36. See *Puvis de Chavannes et le Musée des Beaux-Arts de Marseille*, exh. cat. (Marseille: Musée des Beaux-Arts, 1984–85).

37. For further discussion, see Thomson, *Monet to Matisse*, 65–92.

38. Letter from Cross to Van Rysselberghe, c. 1905, quoted in Herbert, *Neo-Impressionism*, 47.

39. Joachim Gasquet, "Le Paradis de Renoir," *L'Amour de l'art* (February 1921): 41; see also John House, "Renoir and the Earthly Paradise," *Oxford Art Journal* 8, no. 2 (1985): 21–27.

Montparnasse Heads South: Archipenko, Modigliani, Matisse, and WWI Nice

1. An excellent source on wartime Nice is Ralph Jean-Claude Schor, *Nice pendant la guerre de 1914–1918*, Travaux et Mémoires, no. 32 (Aix-en-Provence: Publications des Annales de la Faculté des Lettres, 1964). Quotation on 118.

2. For more, see Georges Dussaule, *Renoir à Cagnes et aux Collettes* (Ville de Cagnes-sur-Mer: Musée Renoir, 1992).

3. See Blaise Cendrars, *Aujourd'hui, 1917–1929, suivi de essais et réflexions, 1910-1916*, ed. Miriam Cendrars (Paris: Denoël, 1987), 17–22 for "J'ai tué" and 11–14 for "Profond aujourd'hui."

4. André Bourin, *Connaissance de Jules Romains, discutée par Jules Romains* (Paris: Flammarion, 1961), 169–70.

5. See Pierre-Marcel Adéma and Michel Décaudin, eds., *Album Apollinaire* (Paris: Gallimard, 1971).

6. Guillaume Apollinaire, *Lettres à Lou*, with preface and notes by Michel Décaudin (Paris: Gallimard, 1970), 16, no. 3, Thursday, October 8, 1914. Apollinaire wrote to a friend that his days and nights in Nice were filled with opium and lovemaking. See Michel Décaudin, ed., *Oeuvres complètes de Guillaume Apollinaire* (Paris: André Balland et Jacques Lecat, 1966), 4:746.

7. For a complete chronology of Apollinaire during the war, see Michel Décaudin, ed., *Guillaume Apollinaire 12: Apollinaire et la Guerre (1)* (Paris: Minard-Letttres Modernes, 1974).

8. In 1918 Cendrars tried to put together a book called *Le Livre du cinéma*. Picasso was to do the cover, and Cocteau, Apollinaire, Romains, Gance, Max Linder, and Chaplin were also to contribute, but the project was never realized. See Blaise Cendrars to Jules Romains, March 20, 1918, in *Jules Romains* (Paris: Bibliothèque Nationale, 1978), 136, no. 512. Regarding Cendrars and Russell, see Gail Levin, "Blaise Cendrars and Morgan Russell: Chronicle of a Friendship," *Dada and Surrealism*, no. 9 (1979): 5–19.

9. Reproduced in Cendrars, *Aujourd'hui, 1917–1929*, 35–40. In "L'ABC du cinéma," he refers to an interview that Abel Gance gave in Nice in which the director talks of the importance of learning the "alphabet" of cinema before one can teach the language. Gance cites "le cut-back" and "le close-up" as being the first two letters of this alphabet.

10. Quoted in James Charters, *This Must Be the Place* (London: Herbert Joseph, 1934), 295.

11. Guillaume Apollinaire to André Level, October 27, 1914, mentions having seen Archipenko in Nice, cited in *Guillaume Apollinaire—André Level, lettres établies présentées par Brigitte Level* (Paris: Aux Lettres Modernes, 1976), 8. References to Archipenko's presence in Nice can be found for every subsequent year: January 4, 1915: in a letter to Serge Férat, Apollinaire mentions having seen Archipenko in Nice (*Oeuvres complètes de Guillaume Apollinaire*, 4:780–81). January 8, 1915: in a letter to Lou, Apollinaire writes that he received a sweater from Archipenko's wife (*Lettres à Lou*, 86). March 1, 1915: in a review, Apollinaire refers to Archipenko's residence in Nice, "Also living in Nice is the sculptor Archipenko, whose wife sends sweaters to their friends in the French army" (Guillaume Apollinaire, *Apollinaire on Art*, ed. Leroy C. Breunig [New York: Da Capo Press, 1988], 440). April 1, 1915: Archipenko is issued a *permis de séjour* for Nice (fig. 19). June 23/July 6, 1916: a Russian document executed at the Consulat Impérial de Russie, Nice, says that Archipenko is exempt from military service. (Reproduced in Donald Karshan, ed., *Alexander Archipenko: International Visionary* [Washington, D.C.: Smithsonian Institution Press, 1969], 30). July 7, 1916: Archipenko is issued an alien resident certificate (reproduced in Karshan, *Archipenko: International Visionary*, 31), which lists his

current address as 13, rue Cronstadt. Early in 1917, Archipenko and Hellens make plans for a collaborative project; Hellens says Archipenko was living at the time on avenue Buenos-Aires (Franz Hellens, *Documents secrets* [Paris: Albin Michel, 1958], 81–85). A tally is made of foreigners living in Nice with a *permis de séjour* in 1917. On the list of Russians are Archipenko and Léopold Sturzwage (Survage). Archipenko's address is listed as 165, Promenade des Anglais. (Archives des Alpes-Maritimes, Nice, 4M 565). November 26, 1917: Russian document referred to above (Karshan, *Alexander Archipenko: International Visionary*, 30) notes that an identity card was issued to Archipenko in Nice on this date. May 9, 1918: Matisse writes to Henri Laurens and mentions having seen Archipenko. See at n. 50. For 1919, see [fig. 19]).

12. Frances Archipenko Gray, the artist's second wife, wrote me on January 8, 1998, that Archipenko described it as tuberculosis of the bone, suffered during childhood.

13. See LeRoy Ellis, *La Colonie russe dans les Alpes-Maritimes des origines à 1939* (Nice: Editions Serre, 1988).

14. Paul Castela and Michel Steve, *Le Château de Valrose* (Nice: Institut d'Etudes Niçoises, 1986).

15. *Philadelphia Museum of Art Bulletin* 37, no. 191 (November 1941): n.p., notes that *Before the Mirror* was made "at Château Valrose above Nice." Mrs. Archipenko recognized Château Valrose when I showed her this photograph. Archipenko had pointed out the building to her when they visited Nice in 1960 and identified it as a place where he had worked.

16. Franz Hellens was grateful to Archipenko for introducing him to Boris Savinkov and his circle in Nice. See Hellens, *Documents Secrets*, 86–87.

17. In *Alexander Archipenko (Elfte Retrospektive Ausstellung). Lyonel Feininger*, exh. cat. (Frankfurt: Kunstsalon Ludwig Schames, 1922), n.p.

18. Alexander Archipenko, "Nature: The Point of Departure," *The Arts* 5 (January 1924): 32.

19. Alexander Archipenko, *Fifty Creative Years, 1908–1958* (New York: Tekhne, 1960), 43.

20. The Cubist sculpture of Henri Laurens and Jacques Lipchitz who were working in Paris is, by comparison, more concerned with space, form, and mass. As Laurens himself summed it up: "Our only concern was that of volume and the exploration of volume. . . . Sculpture is, above all, about taking possession of space, of a space limited by forms." (Yvon Tallandier, "Une declaration de Henri Laurens," *Amis de l'Art*, no. 1 [June 25, 1951]).

21. For an early autobiographical statement by Survage in English, see Samuel Putnam, *The Glistening Bridge: Léopold Survage and the Spatial Problem in Painting* (New York: Covic-Friede Publishers, 1929), 167–74. See also *Survage*, exh. cat. (Lyon: Musée des Beaux-Arts, 1968), 2, 5, 7.

22. *Survage*, 7.

23. Jeanine Warnod, *Léopold Survage* (Brussels: André de Rache, 1983), 117.

24. See a 1913 drawing by Picasso of Survage working on a design for *Les Rythmes colorés*, reproduced in Daniel Abadie, *Survage: Les Années héroiques* (Arcueil: Editions Anthèse, 1993), 126.

25. Blaise Cendrars, "La Parturition des couleurs," *La Rose Rouge* (July 17, 1919), reprinted in Cendrars, *Aujourd'hui, 1917–1929*, 72–74, and in *Léopold Survage, Ecrits sur la peinture*, ed. Hélène Seyrès (Paris: Archipel, 1992), 152–53.

26. *Survage*, 7. Apollinaire urged the artist, né Sturzwage, to Frenchify his surname to Survage.

27. *Apollinaire on Art*, 423.

28. Guillaume Apollinaire, preface to *Léopold Survage*, exh. cat. (Paris: Galerie Bongard, January 21–30, 1917), reprinted in Survage, *Écrits sur la peinture*, 147–49.

29. Ibid., 147, 148.

30. In October 1919 Archipenko and Survage founded with Albert Gleizes an organization called La Section d'Or to reestablish and continue the vitality of Cubism. The name referred to the famous Section d'Or exhibition at the Galerie de la Boétie in October 1912, a major event in the history of Cubism.

31. Hellens, *Documents secrets*, 81–85. For a drawing of Hellens by Archipenko from 1918, see André Lebois, *Franz Hellens* (Paris: Editions Pierre Seghers, 1963), 96.

32. Cendrars dedicated one of his *19 elastic poems* called "Head" to "Archipenko, Nice, 1918" in *Noi*, no. 3 (February 1919). The *Noi* publication is reproduced in Karshan, *Archipenko: International Visionary*, 42.

33. See the brilliant article by Natasha Staller, "'Méliès' Fantastic Cinema and the Origins of Cubism," *Art History* 12 (June 1989): 202–32

34. For the most complete account of Modigliani's time in Nice, see Pierre Sichel, *Modigliani* (New York: E. P. Dutton, 1967), 404–39.

35. The two portraits of Germaine Meyer were executed in the summer of 1918 when she was in Nice with her sister Marcelle and brother-in-law, Pierre Bertin. According to Ornella Volta of the Erik Satie Foundation, Paris, the trio spent July and August 1918 there at 4, rue Croix-de-Marbre (letter to the author, January 23, 1998). See statements touching on Modigliani in Nice by Germaine Survage, Pierre Bertin, Léopold Survage, and Félicie Cendrars in *Modigliani vivo: Testimonianze inedite e rare*, comp. Enzo Maiolino and presented by Vanni Schweiler (Turin: Fògola Editore, 1981).

36. Modot is perhaps best known for his later role in Luis Buñuel's film *Le Chien andalou*. The filmmaker Jacques-Henry Levesque recalled seeing Modigliani, Modot, and Cendrars on the Quai des Etats-Unis in Nice in 1918. See Jacques-Henry Levesque, "Sur Blaise Cendrars, extraits d'un recueil alphabétique," *Mercure de France*, no. 1185 (May 1962): 88–104.

37. Franz Hellens, "Un Voyant," *Mercure de France* 282, no. 953 (March 1, 1938): 323-37. Although the article does not mention Modigliani by name, he is its subject, according to Hellens in *Documents secrets*, 78.

38. The paintings show a fair-haired girl with a thin nose, while photos feature a dark-haired girl with a broad nose.

39. Modigliani's visit to Renoir is recounted in Sichel, *Modigliani*, 409–12.

40. Statement by Survage in *Modigliani vivo: Testimonianze inedite e rare*, 65–68.

41. When I visited Cagnes in July 1997, a guard at the museum in the Château de Cagnes pointed out to me a white house with a tall narrow section and a wider flat section, like the one pictured here, saying that it was where Modigliani lived. That same house is depicted in Emma Segur-Dalloni, "Amédéo Modigliani à Cagnes," *L'Espoir*, August 23, 1962, n.p. See also Patrice Chaplin, *Into the Darkness Laughing: The Story of Jeanne Hébuterne, Modigliani's Last Mistress* (London: Virago, 1990), illus. 11.

42. For an interesting discussion of this change, see Dominique Fourcade, "An Uninterrupted Story," 47–57, in Jack Cowart, ed., *Henri Matisse: The Early Years in Nice, 1916–1930*, exh. cat. (Washington, D.C.: National Gallery of Art; New York: Harry N. Abrams, 1986).

43. For the best material on Matisse, Nice, and Renoir, see Georges Besson, "Arrivée de Matisse à Nice, Matisse et quelques personnages," *Le Point* (special issue on Matisse) 21 (July 1939): 38–43. Also Dominique Fourcade, "Autres propos de Henri Matisse," *Macula* 1 (1976): 92–115, and Jack Flam, ed., *Matisse on Art*, rev. ed. (Berkeley and Los Angeles: University of California Press, 1995).

44. See "Matisse," in *Jules Romains, amitiés et rencontres* (Paris: Flammarion, 1970), 90–94.

45. Besson, "Arrivée de Matisse à Nice."

46. Jules Romains, in Elie Faure, Jules Romains, Charles Vildrac, and Léon Werth, *Henri Matisse* (Paris: Georges Crès, 1920), 19–20.

47. *Romains*, 55.

48. In April and May 1918 Romains finished the second and third versions respectively of his play *Cromedeyre-le-Viel*, which he described as being "a unanimist tragedy that takes place not in a city, but rather in the high valleys of Cévennes, that is to say in a harsh and primitive environment." In the summer of 1918 he also became very interested in "extra-retinal vision," or seeing that does not involve eyes. *Romains*, 57, 88–89.

49. Fourcade, "An Uninterrupted Story."

50. Quoted in *Henri Laurens: Le Cubisme, constructions et papiers collés 1915–1919*, exh. cat. (Paris: Musée National d'Art Moderne, Centre Georges Pompidou, 1985), 20.

THE MEDITERRANEAN MUSE:
ARTISTS ON THE RIVIERA BETWEEN THE WARS

1. Stéphen Liégeard first coined the term *Côte d'Azur* in his book of that name (Paris: Quantin, 1887).

2. See the recent catalogue by Joachim Pissarro, *Monet and the Mediterranean* (New York: Rizzoli, 1997).

3. The most important work concerning twentieth-century artists on the Riviera is the catalogue to the consortium of exhibitions organized on the subject in Nice and the vicinity, in the summer of 1997, *La Côte d'Azur et la modernité, 1918–1958*, exh. cat. (Paris: Réunion des musées nationaux, 1997), as well as my review "An Invented Paradise," *Art in America* 86 (March 1998): 78–87. Four works dealing with the period preceding the one with which I am concerned are also important for any study of modern art on the Riviera: Judi Freeman et al., *The Fauve Landscape*, exh. cat. (Los Angeles: Los Angeles County Museum of Art; New York: Abbeville, 1990); James D. Herbert, *Fauve Painting: The Making of Cultural Politics* (New Haven and London: Yale University Press, 1992); Richard Thomson, *Monet to Matisse: Landscape Painting in France, 1874–1914*, exh. cat. (Edinburgh: National Gallery of Scotland, 1994); and *Peintres de la couleur en Provence: 1875–1920*, exh. cat. (Paris: Réunion des musées nationaux, 1995).

4. For this subject and many others, the best cultural history of the Riviera is Mary Blume, *Côte d'Azur: Inventing the French Riviera* (London: Thames and Hudson, 1992).

5. For the Jetée-Promenade, see Jacques Borgé and Nicolas Viasnoff, *Archives de la Côte d'Azur* (Paris: Editions Michèle Trinckvel, 1994), 8–12, and Guy Junien Moreau, *Le Casino de la Jetée Promenade: Naissance, vies et morts des deux palais* (Nice: Editions Gilletta, 1993).

6. See *At Home Abroad: William Glackens in France, 1925–1932*, exh. cat. (New York: Kraushaar, 1997).

7. Lartigue wrote of Saint-Tropez, in his diary in 1933: "Saint-Tropez was the little violet vendor discovered by the stylish painter. The violet vendor is now a parvenu. She's a fattened-up bourgeoise disguised as a violet vendor to continue to please the painter, himself done up like a poor art student to please the violet vendor." Jacques-Henri Lartigue, *L'Oeil de la mémoire* (Paris: Carrère/Lafon, 1986), 86.

8. Some of my discussion of Lartigue resembles the dust-jacket copy I wrote for *Lartigue's Riviera* (Paris and New York: Flammarion, 1997), with excellent picture selection by Martine d'Astier and a superb text by Mary Blume.

9. Beaumont Newhall, *The History of Photography* (New York: The Museum of Modern Art, 1982), 225.

10. See Andrew Wilton and Ilaria Bignamini, eds., *Grand Tour: The Lure of Italy in the Eighteenth Century*, exh. cat. (London: Tate Gallery, 1996), and Ian Jenkins and Kim Sloan, *Vases and Volcanoes: Sir William Hamilton and His Collection*, exh. cat. (London: The British Museum, 1996).

11. See the excellent catalogue *Le Pont Transbordeur et la vision moderniste*, exh. cat. (Marseille: Musées de Marseille; Paris: Réunion des musées nationaux, 1991), with essays by Bernard Millet, Nathalie Abou-Isaac, Andreas Haus, and Krisztine Passuth.

12. Lise Curel, "Côte d'Azur," *Regards* 4, no. 59 (February 1935), cited in Ann Thomas, *Lisette Model*, exh. cat. (Ottawa: National Gallery of Canada, 1990), 50.

13. See *Henri Matisse: The Early Years in Nice, 1916–1930*, exh. cat. (Washington, D.C.: National Gallery of Art, 1986), and my review of the exhibition, "Matisse's Retour à l'Ordre," *Art in America* 75 (June 1987): 110–23, 167, 169.

14. André Breton, in reference to "a new *Fenêtre* by Matisse," excoriated the artist for his 1920s work and found him and Derain to be "discouraged and discouraging." "Le Surréalisme et la peinture," *La Révolution Surréaliste* 6, no. 6 (March 1, 1926): 31.

CHÂTEAU AND VILLA LIFE

1. Mary Blume, *Côte d'Azur: Inventing the French Riviera* (New York: Thames and Hudson, 1992), 88, illus. 43, 44.

2. On Americans in France during this period, see Elizabeth Hutton Turner, ed., *Americans in Paris: Man Ray, Gerald Murphy, Stuart Davis, and Alexander Calder* (Washington, D.C.: Counterpoint, in association with the Phillips Collection, 1996). On the strength of the dollar against the franc, see Honoria Murphy Donnelly with Richard N. Billings, *Sara and Gerald: Villa America and After* (New York: Times Books, 1982), 44.

3. In the twenty-fifth anniversary report of the Harvard class of 1901, Greeley reported the following:

> After graduation I took a few architectural courses in the Graduate School, and then began to study painting. In 1906 I went abroad, and for fifteen years made my headquarters in Paris. After the outbreak of the War, I worked for several months in a hospital in Houlgate, and then became interested with a few other Americans in the relief work of the American Distributing Service in Paris.
>
> Since 1920 I have lived most of the time in the south of France, where I have continued to paint. Several months ago I bought property near Grasse, and I am now occupied with improving it and restoring the farms to their former state of productiveness. I expect to live here all the year round, as I have left Paris definitely.

The June 1946 report to the Class of '01 noted that Greeley had left France for Switzerland a few months before the war broke out. He died in Geneva on May 16, 1956. The Harvard University Archives contain a few clippings concerning Greeley's heroic relief work during World War I.

4. See Simon Blow, "The Merchant Prince," *Connoisseur* 222, no. 961 (February 1992): 54ff. The article profiles Peter Wilson, who made Sotheby's a household name, and discusses at length Château de Clavary, which he purchased in 1961.

5. Nina Hamnett, *Laughing Torso: Reminiscences of Nina Hamnett* (New York: Ray Long & Richard R. Smith, 1932), 308–09. Full disucssion of Clavary, 308-320. She refers to her hosts simply as "F." and "R.," perhaps

to be discreet, and does not mention Clavary by name. Her biographer confirms, though, that she is in fact referring to François de Gouy d'Arcy, Russell Greeley, and the Château de Clavary: Denise Hooker, *Nina Hamnett: Queen of Bohemia* (London: Constable, 1986).

6. Jean Hugo, *Avant d'oublier, 1918–1931* (Paris: Editions Fayard, 1976), 205–8. See also Jean Hugo, *Le Regard de la mémoire* (Arles and Martigues: Actes Sud, 1983). His books say that he visited Clavary in "August." According to the guest book, it was August 1926.

7. Hamnett, *Laughing Torso*, 311.

8. Ibid., 314–15.

9. Ibid., 312.

10. On Wood, see André Cariou and Michael Tooby, *Christopher Wood: A Painter between Two Cornwalls*, exh. cat. (London: Tate Gallery, 1997).

11. All of these individuals signed the guest book except for Igor Stravinsky. The guest book extends from 1926 to 1938. Space does not permit me to list all the names in the book, or the dates on which people signed it, except for a few: Nina Hamnett on March 17, 1926; Francis Poulenc in March 1926; Marie Laurencin on May 1, 1926.

12. Max Jacob to Francis Poulenc, March 30, 1926, in Francis Poulenc, *Correspondance, 1915–1963*, presented by Hélène de Wendel (Paris: Editions du Seuil, 1967), 72–73.

13. Hamnett refers to it in *Laughing Torso*, 310: "After dinner, we sat in a little room which has now, I believe, a mosaic floor designed by Picasso." The drawing that relates to this mosaic can be found in a book written in 1936 by Max Jacob, *La Chronique des temps héroiques* (Paris: L. Broder, 1956), and in *Les Lettres Françaises*, October 25, 1956, 11.

14. Blow, "The Merchant Prince."

15. On the Murphys, see Calvin Tomkins, *Living Well Is the Best Revenge* (New York: Viking Press, 1971); Donnelly with Billings, *Sara and Gerald*; Linda Patterson Miller, ed., *Letters from the Lost Generation: Gerald and Sara Murphy and Friends* (New Brunswick, N.J., and London: Rutgers University Press, 1991); and Amanda Vaill, *Everybody Was So Young: Gerald and Sara Murphy, a Lost Generation Love Story* (New York: Houghton Mifflin, 1998).

16. On his art, see William Rubin, *The Paintings of Gerald Murphy*, exh. cat. (New York: The Museum of Modern Art, 1974); Wanda M. Corn, "Identity, Modernism, and the American Artist after World War I: Gerald Murphy and *Américanisme*," in Richard A. Etlin, ed., *Nationalism in the Visual Arts*, Studies in the History of Art, 29 (Washington, D.C.: National Gallery of Art/Center for Advanced Studies in the Visual Arts, 1991), 148–69; and Turner, ed., *Americans in Paris*.

17. Quoted in Tomkins, *Living Well*, 6–7.

18. Ibid., 8.

19. Cécile Briolle, Agnès Fuzibet, Gérard Monnier, *Rob Mallet-Stevens, La Villa Noailles* (Marseille: Editions Parenthèses, 1990). See also Dorothée Imbert, *The Modernist Garden in France* (New Haven and London: Yale University Press, 1993).

20. Ibid., 90.

21. See *Picabia et la Côte d'Azur*, exh. cat. (Nice: Musée d'Art Moderne et d'Art Contemporain, 1991).

22. Germaine Everling, *L'Anneau de Saturne* (Paris: Editions Fayard, 1970), esp. chap. 29, "Vie de château," 165–70.

23. Ibid.

CHECKLIST

Number in parentheses with entry refers to the page on which the work is illustrated.

1. ALEXANDER ARCHIPENKO
United States (born Ukraine, worked in France), 1887–1964
Flat Torso, 1914 (p. 33)
Marble on alabaster base, 18 3/4 x 4 1/2 x 4 1/2 in.; including artist's
base: 3 3/4 x 4 1/2 x 4 1/2 in.
Hirshhorn Museum and Sculpture Garden, Smithsonian Institution.
Gift of Joseph H. Hirshhorn, 1966

2. ALEXANDER ARCHIPENKO
Before the Mirror (In the Boudoir), 1915 (p. 31)
Oil, graphite, photograph, and metal on panel, 18 x 12 in.
Philadelphia Museum of Art. Gift of Christian Brinton, 1941.079.119

3. ALEXANDER ARCHIPENKO
Seated Woman Combing Her Hair, 1915 (p. 32)
Bronze, ed. 4/8, 21 1/8 in. high
Frances Archipenko Gray

4. ALEXANDER ARCHIPENKO
Standing Figure, 1916 (p. 33)
Faïence, approximately 12 in. high
Frances Archipenko Gray

5. ALEXANDER ARCHIPENKO
Woman Combing Her Hair, 1916 (p. 30)
Bronze, ed. 10/12, 13 11/16 in. high
Private collection

6. MILTON AVERY
United States, 1885–1965
March on the Balcony, 1952 (p. 50)
Oil on canvas, 44 x 34 1/8 in.
The Phillips Collection, Washington, D.C.

7. MAX BECKMANN
Germany, 1884–1950
Beaulieu, 1947 (p. 58)
Oil on canvas, 31 5/8 x 39 3/8 in.
Krannert Art Museum and Kinkead Pavilion, University of Illinois,
Champaign

8. PIERRE BONNARD
France, 1867–1947
Paysage du Midi (Landscape in the Midi), 1926 (p. 59)
Oil on canvas, 20 1/4 x 16 1/2 in.
Yale University Art Gallery. Bequest of Edith Malvina K. Wetmore,
1966.79.1

9. GEORGES BRAQUE
France, 1882–1963
Bateaux sur la plage, L'Estaque (Boats on the Beach, L'Estaque),
autumn 1906 (p. 23)
Oil on canvas, 19 1/2 x 27 5/8 in.
Los Angeles County Museum of Art. Gift of Anatole Litvak, 53.55.1

10. GEORGES BRAQUE
Landscape, L'Estaque, autumn 1906 (p. 22)
Oil on canvas, 20 x 23 3/4 in.
New Orleans Museum of Art. Bequest of Victor K. Kiam, 77.284

11. BRASSAÏ (GYULA HALÁSZ)
Hungary (worked in France), 1899–1984
Côte d'Azur/L'Ombrelle, Menton (Côte d'Azur/the Umbrella, Menton),
1934 (p. 48)
Gelatin silver print, 11 9/32 x 8 29/32 in.
The J. Paul Getty Museum, Los Angeles, 84.XM.1024.7

12. HENRI CARTIER-BRESSON
France, born 1908
Hyères, France, 1932 (p. 56)
Gelatin silver print, 13 1/4 x 19 3/4 in.
George Eastman House, 77:759:2

13. HENRI CARTIER-BRESSON
Hyères, France, 1932
Gelatin silver print, 6 1/16 x 9 5/16 in.
The J. Paul Getty Museum, Los Angeles, 85.XM.400.1

14. PAUL CÉZANNE
France, 1839–1906
Arbres au Jas de Bouffan (Trees in the Jas de Bouffan),
circa 1875–76 (p. 13)
Oil on canvas, 21 3/8 x 28 7/8 in.
Scott M. Black Collection

15. HENRI-EDMOND CROSS
France, 1856–1910
Coast near Antibes, 1891/1892
Oil on canvas, 25 5/8 x 36 3/8 in.
National Gallery of Art, Washington. John Hay Whitney Collection,
1982.76.2

16. HENRI-EDMOND CROSS
Antibes, Après-Midi (Antibes in the Afternoon), 1908 (p. 15)
Oil on canvas, 31 7/8 x 39 3/8 in.
Scott M. Black Collection

17. RAOUL DUFY
France, 1877–1953
Barques aux Martigues (Boats in Martigues), 1907 (p. 19)
Oil on canvas, 25 x 31 3/4 in.
Scott M. Black Collection

18. RAOUL DUFY
Le Bal du 14 Juillet à Vence (The July 14th Dance in Vence), 1920 (p. 46)
Oil on canvas, 21 1/2 x 26 in.
Portland Museum of Art, Maine. Lent by Mildred Otten, The Albert
Otten Collection, 10.1993.71

19. RAOUL DUFY
Fontaine à Hyères (Fountain at Hyères), circa 1927–28 (p. 39)
Oil on canvas, 18 x 14 7/8 in.
Colby College Museum of Art, Waterville, Maine. Gift of Miss
Adeline F. and Miss Caroline R. Wing, XX-P-013

20. RAOUL DUFY
Nice, La Baie des Anges (Nice, the Bay of Angels), 1932 (p. 38)
Oil on canvas, 14 7/8 x 18 in.
The Metropolitan Museum of Art. Bequest of Miss Adelaide Milton
de Groot (1876–1967), 1967. (67.187.67)

21. EMILE-OTHON FRIESZ
France, 1879–1949
La Calanque de Figuerolles (Inlet at Figuerolles), 1907
Oil on canvas, 25 1/2 x 32 in.
Private collection

22. WILLIAM J. GLACKENS
United States, 1870–1938
Bowlers, La Ciotat, 1930 (p. 43)
Oil on canvas, 25 x 30 in.
Museum of Art, Fort Lauderdale, Florida. Ira Glackens Bequest, 92.31

23. WILLIAM J. GLACKENS
Fête du Suquet (The Suquet Festival), 1932 (p. 47)
Oil on canvas, 25 3/4 x 32 in.
Whitney Museum of American Art, New York. Purchase, 33.13

24. MARSDEN HARTLEY
United States, 1877–1943
Purple Mountains, Vence, 1924 (p. 42)
Oil on canvas, 25 1/2 x 32 in.
Phoenix Art Museum. Gift of Mr. and Mrs. Orme Lewis, 77.147

25. JACQUES-HENRI LARTIGUE
France, 1894–1986
La Jetée, Promenade de Nuit, Nice (The Jetée–Promenade, Nice, by Night),
April 1911
Gelatin silver print, 16 x 12 in.
Association des Amis de Jacques-Henri Lartigue, Paris, 1911-197

26. JACQUES-HENRI LARTIGUE
Hôtel Ruhl, Nice, March 1919
Gelatin silver print, 16 x 12 in.
Association des Amis de Jacques-Henri Lartigue, Paris, 1919-064

27. JACQUES-HENRI LARTIGUE
Bibi, Cap d'Antibes, May 1920 (p. 45)
Gelatin silver print, 12 x 16 in.
Association des Amis de Jacques-Henri Lartigue, Paris, 1920-056

28. JACQUES-HENRI LARTIGUE
Bibi, Cannes, January 1923 (p. 44)
Gelatin silver print, 12 x 16 in.
Association des Amis de Jacques-Henri Lartigue, Paris, 1923-046

29. JACQUES-HENRI LARTIGUE
Tempête à Nice (Storm in Nice), 1925 (p. 40)
Gelatin silver print, 12 x 16 in.
Association des Amis de Jacques-Henri Lartigue, Paris, 1925-1

30. JACQUES-HENRI LARTIGUE
Véra, Bibi, et Arlette, Cannes, May 1927
Gelatin silver print, 12 x 16 in.
Association des Amis de Jacques-Henri Lartigue, Paris, 1927-145

31. JACQUES-HENRI LARTIGUE
La Méditerranée (The Mediterranean), September 1927 (p. 41)
Gelatin silver print, 12 x 16 in.
Association des Amis de Jacques-Henri Lartigue, Paris, 1927-186

32. JACQUES-HENRI LARTIGUE
Abel Gance, Beauvallon, 1927 (p. 49)
Gelatin silver print, 16 x 12 in.
Association des Amis de Jacques-Henri Lartigue, Paris, 1927-038

33. JACQUES-HENRI LARTIGUE
Cannes, April 1929 (p. 52)
Gelatin silver print, 10 1/2 in. diameter
Association des Amis de Jacques-Henri Lartigue, Paris, 1929-041

34. JACQUES-HENRI LARTIGUE
Renée, Juan-les-Pins, May 1930 (p. 53)
Gelatin silver print, 16 x 12 in.
Association des Amis de Jacques-Henri Lartigue, Paris, 1930-014

35. JACQUES-HENRI LARTIGUE
*Tournage du film, "Les Aventures du Roi Pausole," Cap d'Antibes (Filming of
"The Adventures of King Pausole," Cap d'Antibes)*, August 1932 (p. 53)
Gelatin silver print, 16 x 12 in.
Association des Amis de Jacques-Henri Lartigue, Paris, 1932-024

36. JACQUES-HENRI LARTIGUE
Mary Belewsky, Cap d'Antibes, May 1941 (p. 49)
Gelatin silver print, 16 x 12 in.
Association des Amis de Jacques-Henri Lartigue, Paris, 1941-004

37. ARISTIDE MAILLOL
France, 1861–1944
Head of Auguste Renoir, circa 1908
Bronze, 16 in. high
Portland Museum of Art, Maine. Lent by Mildred Otten, The Albert
Otten Collection, 10.1993.71

38. MAN RAY (EMMANUEL RADNITSKY)
United States, 1890–1976
Le Cannet, Landscape of the Midi (Paysage du Midi), 1923 (p. 59)
Gelatin silver print, 10 5/8 x 8 7/16 in.
The J. Paul Getty Museum, Los Angeles, 84.XM.1000.44

39. MAN RAY
Magnolia Blossoms, Antibes, 1926
Gelatin silver print, 10 5/8 x 9 in.
The Detroit Institute of Arts. Founders Society Purchase, Henry E. and
Consuelo S. Wenger Foundation Fund and Mr. and Mrs. Conrad H.
Smith Memorial Fund, F80.4

40. HENRI MATISSE
France, 1869–1954
*Femme assise, le dos tourné vers la fenêtre ouverte (Seated Woman, Back Turned
to the Open Window)*, circa 1922 (p. 51)
Oil on canvas, 28 3/4 x 36 1/2 in.
The Montreal Museum of Fine Arts. Purchase, John W. Tempest Fund,
1949.1015

41. HENRI MATISSE
La Séance de Trois Heures (The Three O'Clock Sitting), 1924 (p. 55)
Oil on canvas, 36 1/4 x 28 3/4 in.
Portland Museum of Art, Maine. Lent anonymously, L36

42. HENRI MATISSE
Vase de Fleurs devant la Fenêtre (Vase of Flowers before a Window), 1924
Oil on canvas, 23 7/8 x 29 in.
Museum of Fine Arts, Boston. Bequest of John T. Spaulding, 48.577

43. HENRI MATISSE
Woman in the Window, Nice, 1926 (p. 54)
Oil on canvas, 28 1/2 x 23 1/2 in.
The Saltzman Family

44. LISETTE MODEL
United States (born Austria), 1901–1983
Promenade des Anglais, Nice, circa 1934 (p. 48)
Gelatin silver print, 11 3/8 x 9 1/8 in.
The J. Paul Getty Museum, Los Angeles, 84.XM.153.52

45. LISETTE MODEL
Promenade des Anglais, Nice, circa 1934
Gelatin silver print, 11 5/16 x 8 5/8 in.
The J. Paul Getty Museum, Los Angeles, 84.XM.153.56

46. LISETTE MODEL
Promenade des Anglais, Nice circa 1934
Gelatin silver print, 11 3/8 x 9 1/8 in.
The J. Paul Getty Museum, Los Angeles, 84.XM.153.11

47. AMEDEO MODIGLIANI
Italy (worked in France), 1884–1920
The Boy (or Youth in a Blue Jacket), 1918 or 1919 (p. 34)
Oil on canvas, 36 1/4 x 23 3/4 in.
Indianapolis Museum of Art. Gift of Mrs. Julian Bobbs in memory of
William Ray Adams, 46.22

48. AMEDEO MODIGLIANI
Paysage à Cagnes (Landscape in Cagnes), 1919 (p. 35)
Oil on canvas, 18 1/8 x 11 1/2 in.
Katherine M. Perls

49. LÁSZLÓ MOHOLY-NAGY
United States (born Hungary, worked in France), 1895–1946
Marseille, Port View [Old Harbour], 1929 (p. 57)
Gelatin silver print, 19 1/4 x 14 3/4 in.
George Eastman House, 81:2163:43

50. CLAUDE MONET
France, 1840–1926
Bordighera, 1884 (p. 6)
Oil on canvas, 25 1/2 x 32 in.
The Art Institute of Chicago. Potter Palmer Collection, 1922.426

51. CLAUDE MONET
Cap Martin, near Menton, 1884 (p. 12)
Oil on canvas, 26 1/2 x 32 1/8 in.
Museum of Fine Arts, Boston. Juliana Cheney Edwards Collection,
25.128

52. CLAUDE MONET
Monte Carlo vu de Roquebrune (Monte Carlo seen from Roquebrune), 1884 (p. 2
Oil on canvas, 25 7/8 x 32 in.
Scott M. Black Collection

53. CLAUDE MONET
The Mediterranean (Cap d'Antibes), 1888 (p. 11)
Oil on canvas, 25 5/8 x 32 in.
Columbus Museum of Art, Ohio. Bequest of Frederick W. Schumacher,
[57] 47.093

54. CLAUDE MONET
Plage de Juan-les-Pins (Beach at Juan-les-Pins), 1888 (p. 9)
Oil on canvas, 28 3/4 x 36 1/4 in.
Acquavella Galleries, Inc.

55. EDVARD MUNCH
Norway, 1863–1944
By the Roulette, 1892
Oil on canvas, 29 3/4 x 45 1/2 in.
Munch Museum, Oslo, M 50

56. EDVARD MUNCH
The Beach at Nice, 1892 (p. 21)
Oil on canvas, 18 1/4 x 27 in.
Munch Museum, Oslo, M 1076

57. PABLO PICASSO
Spain (worked in France), 1881–1973
Vase, 1950
Terracotta, 26 in. high
Portland Museum of Art, Maine. Anonymous Gift, 1985.323

58. PABLO PICASSO
Vase, 1950
Terracotta, 28 7/8 in. high
Portland Museum of Art, Maine. Anonymous Gift, 1985.324

59. PIERRE-AUGUSTE RENIOR
France, 1841–1919
L'Estaque, circa 1890 (p. 18)
Oil on canvas, 18 3/8 x 21 7/8 in.
Portland Museum of Art, Maine. Gift of Mr. and Mrs. A. Varick Stout
in memory of Mr. and Mrs. Phineas W. Sprague, 1975.451

60. PIERRE-AUGUSTE RENIOR
The Beach at Le Lavandou, French Riviera, 1894 (front and back covers)
Oil on canvas, 18 1/8 x 21 15/16 in.
Sterling and Francine Clark Art Institute. Gift of Halleck and Sarah
Barney Lefferts, 1964.9

61. PIERRE-AUGUSTE RENIOR
Les Vignes à Cagnes (Vines in Cagnes), 1906 (p. 24)
Oil on canvas, 18 1/4 x 21 3/4 in.
Brooklyn Museum of Art. Gift of Colonel and Mrs. E. W. Garbisch,
51.219

62. PIERRE-AUGUSTE RENIOR
Landscape at Cagnes, 1910 (p. 17)
Oil on canvas, 21 3/8 x 25 3/4 in.
The Toledo Museum of Art. Gift of Mrs. C. Lockhart McKelvy,
1962.1

63. PIERRE-AUGUSTE RENIOR
The Farm at Les Collettes, Cagnes, circa 1914 (p. 20)
Oil on canvas, 21 1/2 x 25 3/4 in.
The Metropolitan Museum of Art. Bequest of Charlotte Gina Abrams,
in memory of her husband, Lucien Abrams, 1961, 61.190

64. THÉODORE VAN RYSSELBERGHE
Belgium, 1862–1926
La Régate (The Regatta), 1892 (p. 14)
Oil on canvas with painted wood liner, 23 7/8 x 31 3/4 in.
Scott M. Black Collection

65. PAUL SIGNAC
France, 1863–1935
Antibes, le Nuage Rose (Antibes, the Pink Cloud), 1916 (p. 16)
Oil on canvas, 28 x 35 in.
Scott M. Black Collection

66. CHAIM SOUTINE
Lithuania (worked in France), 1893–1943
Landscape at Cagnes, circa 1923
Oil on canvas, 24 x 33 in.
The Art Institute of Chicago. Charles H. and Mary F. S. Worcester
Collection, 1947.114.

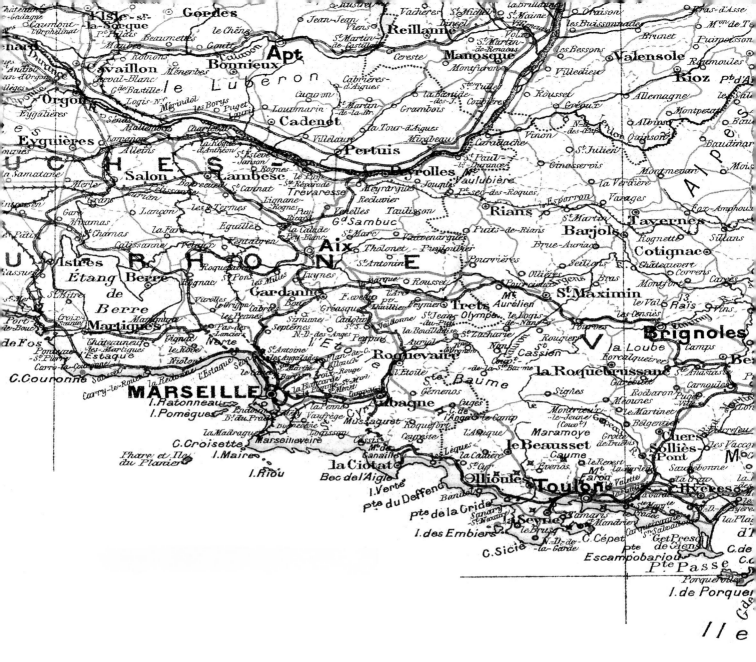

Map courtesy of Harvard Map Collection, Harvard College Library

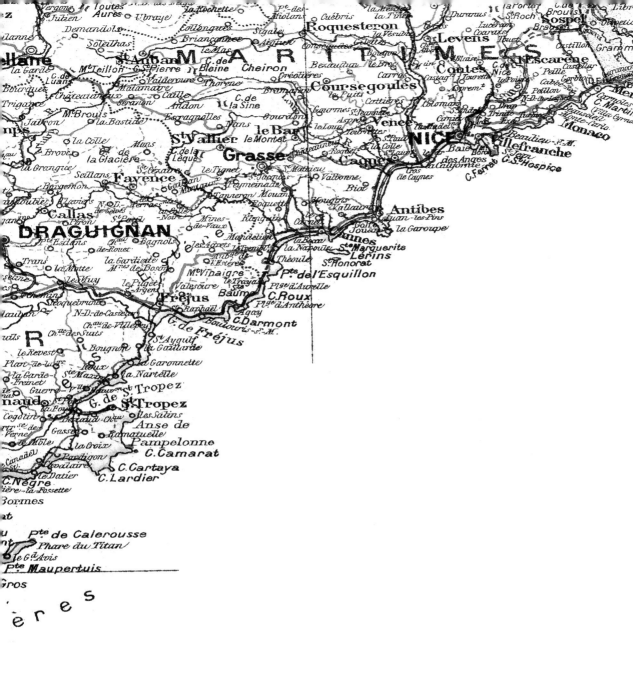

Los Angeles County Museum of Art

The Metropolitan Museum of Art, New York

The Montreal Museum of Fine Arts

Munch Museum, Oslo

Museum of Art, Fort Lauderdale, Florida

Museum of Fine Arts, Boston

National Gallery of Art, Washington

New Orleans Museum of Art

Katherine M. Perls

Philadelphia Museum of Art

The Phillips Collection, Washington, D.C.

Phoenix Art Museum

The Saltzman Family

The Toledo Museum of Art

Whitney Museum of American Art, New York

Yale University Art Gallery, New Haven, Connecticut

and various private collections

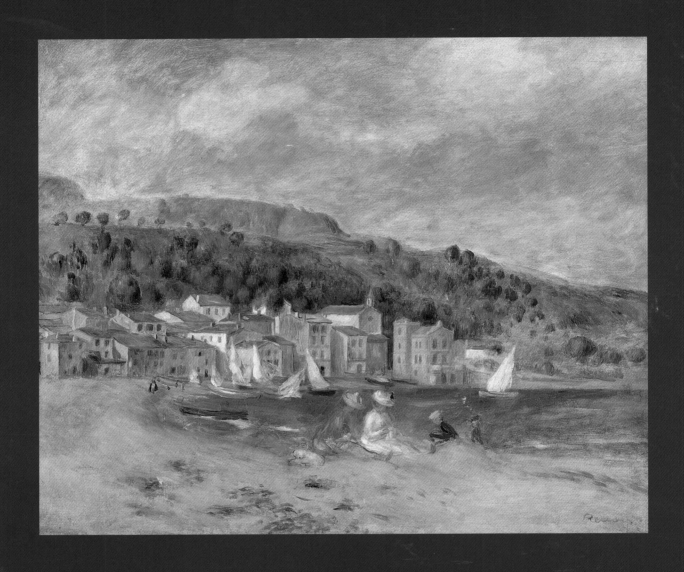

CONTRIBUTORS TO THE CATALOGUE
John House is a Professor at the Courtauld Institute of Art, London, where he is also the Deputy Director.
Kenneth E. Silver is an Associate Professor of Fine Arts at New York University.
Kenneth Wayne is the Joan Whitney Payson Curator at the Portland Museum of Art.

PORTLAND MUSEUM OF ART
SEVEN CONGRESS SQUARE, PORTLAND, MAINE